DOGS IN CARS

Lara Jo Regan

THE COUNTRYMAN PRESS · WOODSTOCK, VT.

Published by The Countryman Press,
P.O. Box 748, Woodstock, VT 05091
Distributed by W. W. Norton & Company, Inc.,
500 Fifth Avenue, New York, NY 10110

Produced by Myth and Matter Media, Los Angeles
Jacket & Book Design: Mika Mingasson
Front Cover Design: Nick Caruso
Editor: Ann Treistman

Dogs in Cars
ISBN 978-1-58157-279-7

Printed in China

10 9 8 7 6 5 4 3 2 1

To my pack: David, Dannie, Bearlie, Daisy, Uncle Max and Mr. Winkle.

I can't imagine the journey without you.

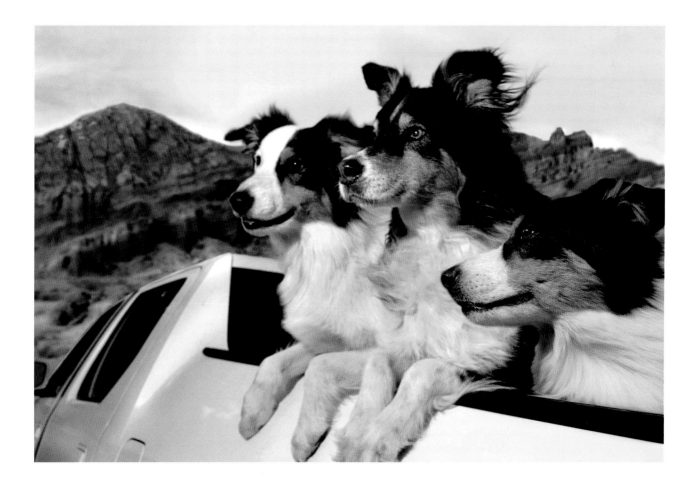

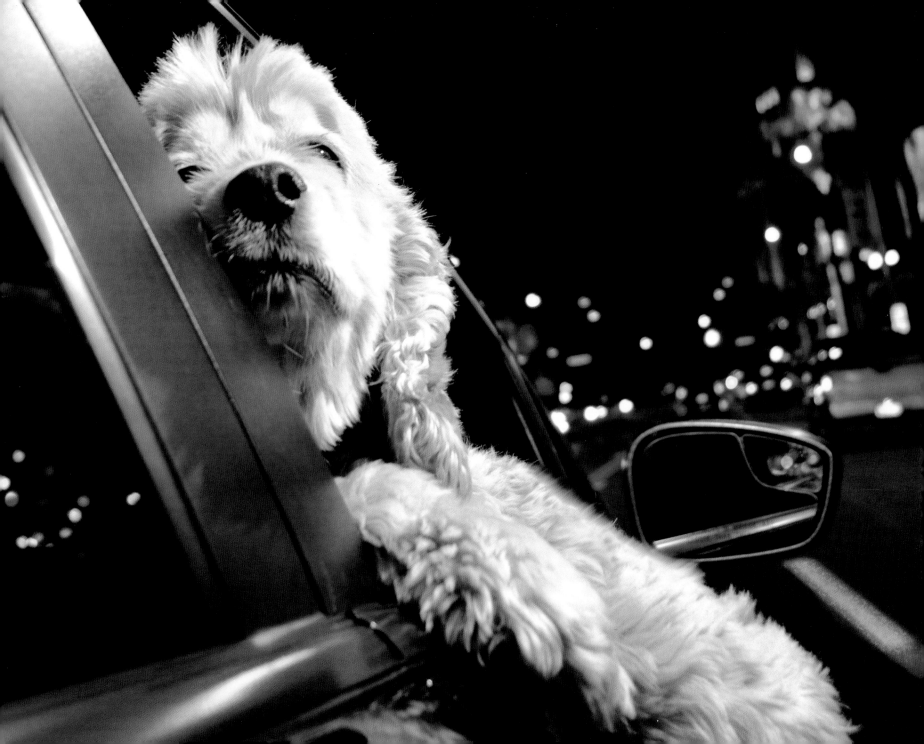

ROUTE

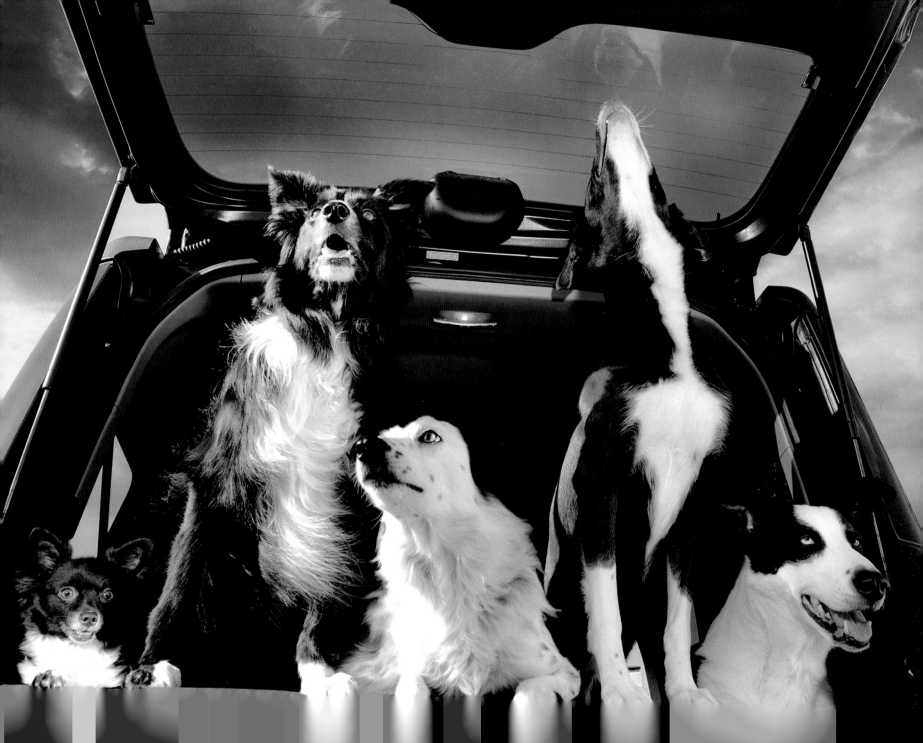

Introduction

Scientists have recently surmised that the childlike nature of dogs can be largely attributed to the absence of a genetic marker for aggression never shed by their more jaded, shrewd cousin, the wolf. This fortuitous evolutionary omission is apparently what gives our canine companions their endearing and enduring enthusiasm. It is no wonder dogs make us smile: they are forever young.

Nowhere is this quality more amplified than when a dog is on a car ride—or even anticipating one. Their already excitable nature becomes downright delirious.

What is it about the vehicular experience that launches Fido into a frenzy? The smorgasbord of passing smells and scenery? The feeling of being on an adventure with the pack? Perhaps it's a souped-up, psychedelic version of their ancient compulsion to roam.

This photographic series is my attempt to capture and transmit the pure joy of a dog in its most heightened state, while exploring the hypnotic visual possibilities of juxtaposing wind-blown fur, steel, leather, vinyl, chrome, wet noses, bulging eyes, PVC, slobber, scenery, speed and euphoria.

I hope the infectious joy of these gorgeous and remarkable creatures rubs off on you.

Thanks for coming along for the ride.

Lara Jo Regan

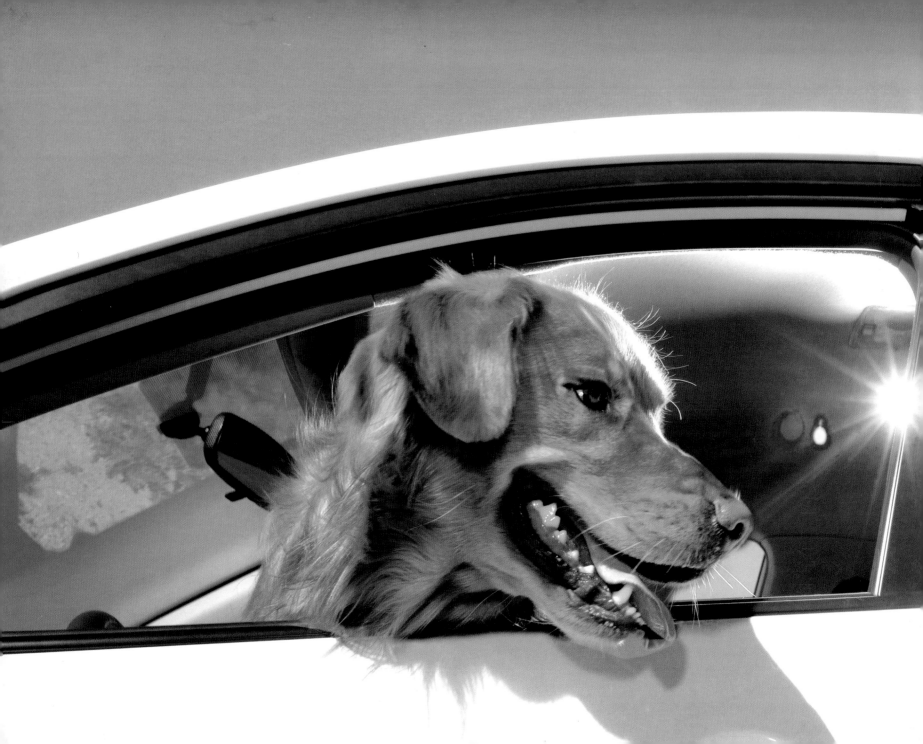

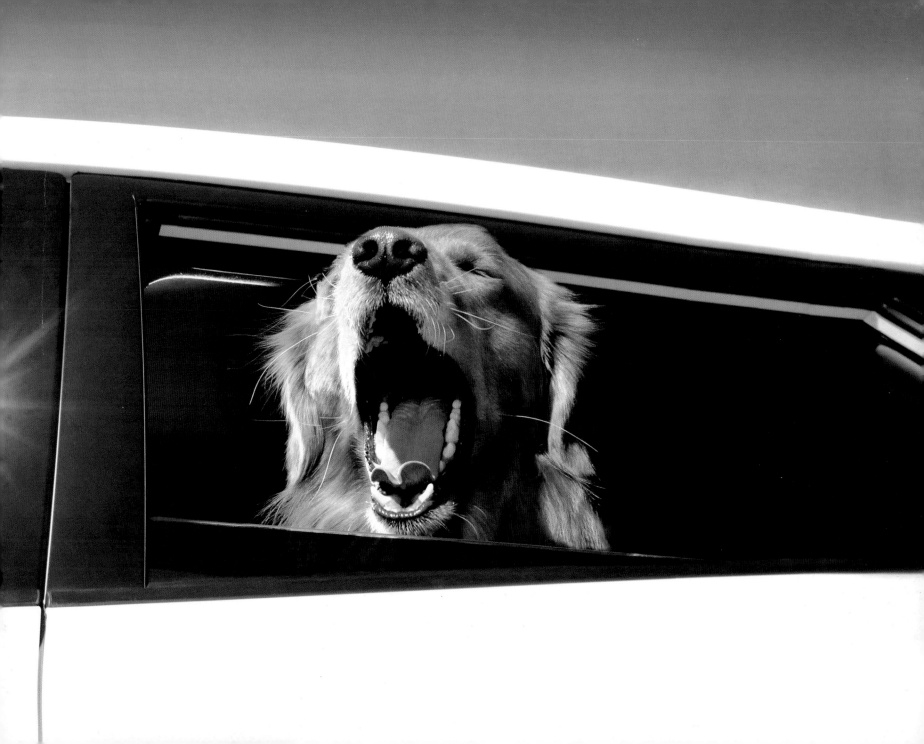

CHAMP & JORDAN *Golden Retrievers*

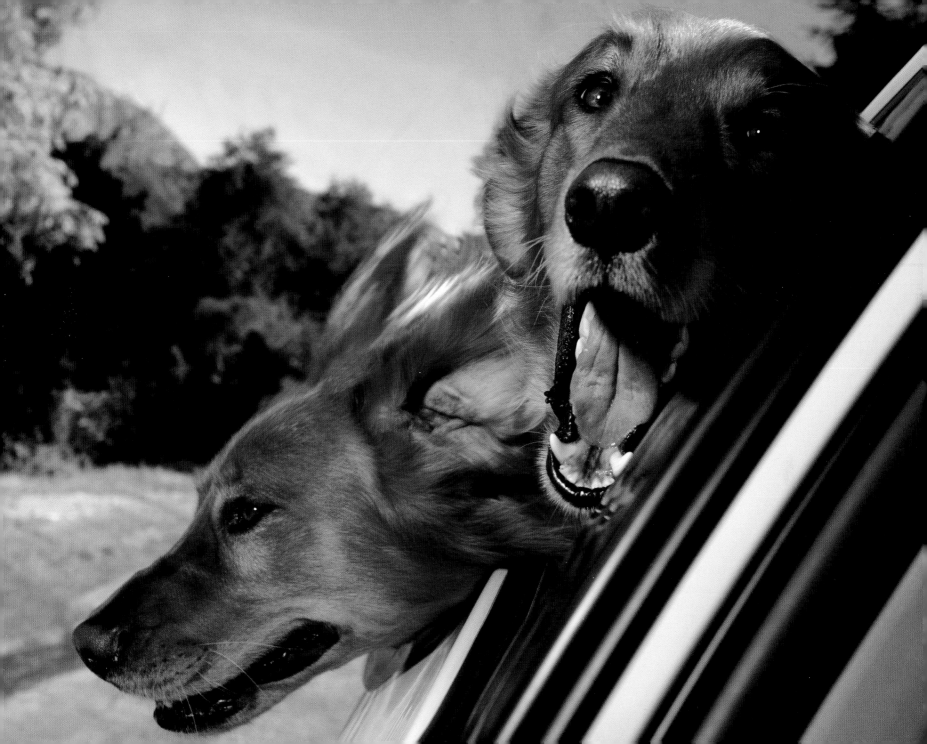

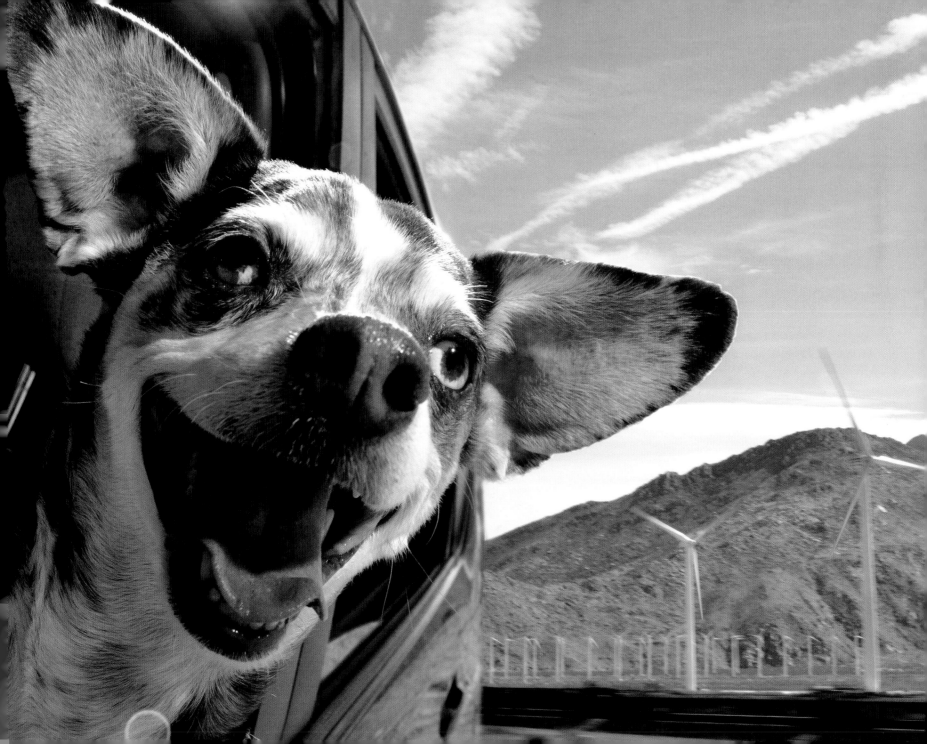

CHULO *Dapple Chiweenie*

BOO *Pit-Terrier Mix*

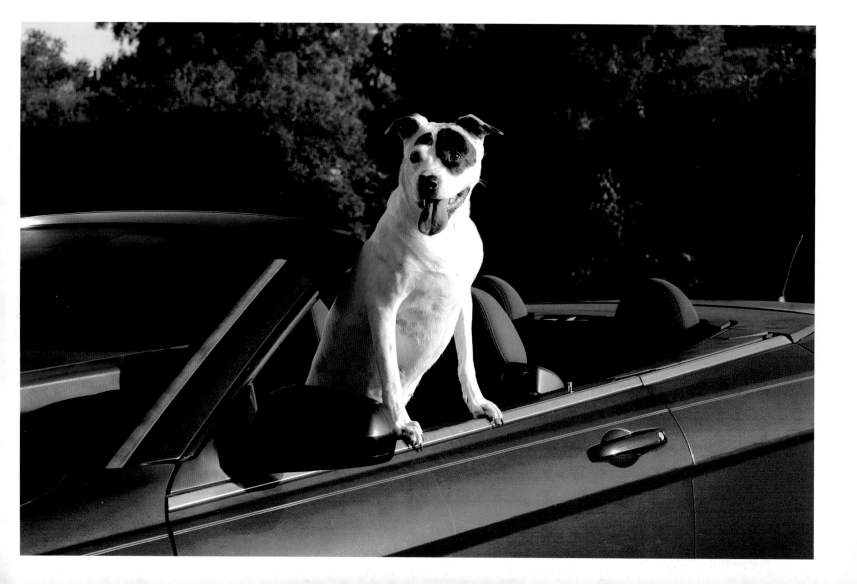

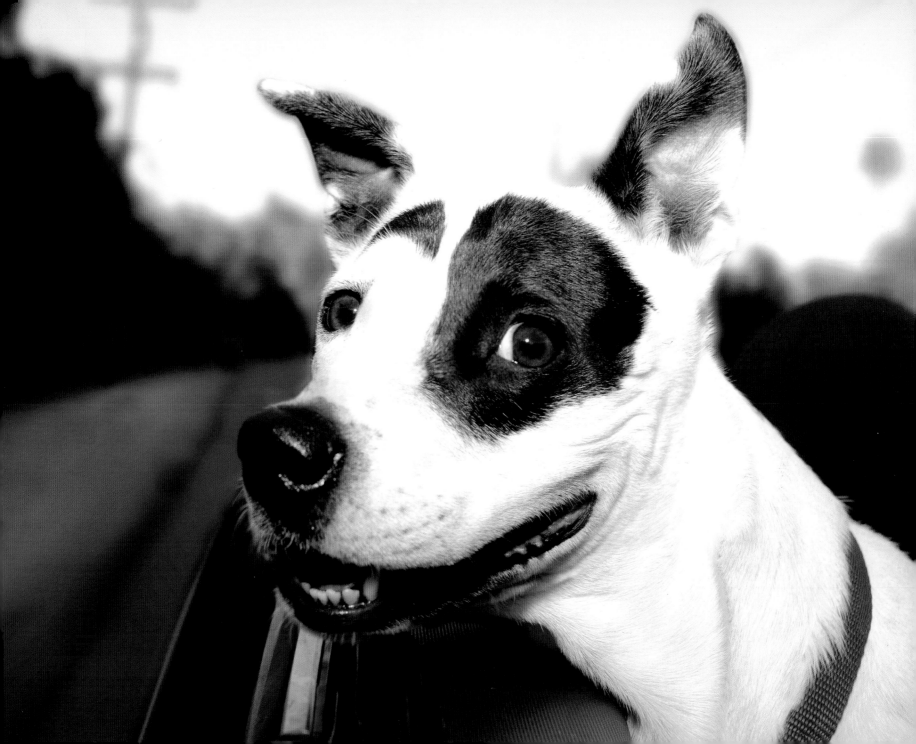

OLIVIER *King Charles Spaniel*

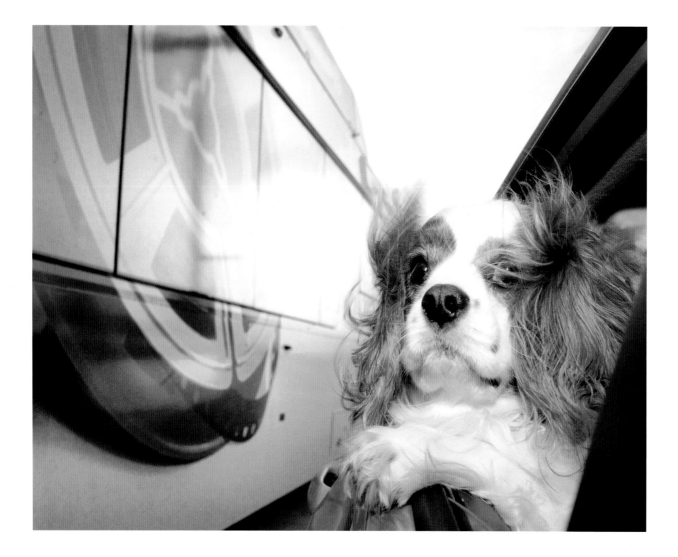

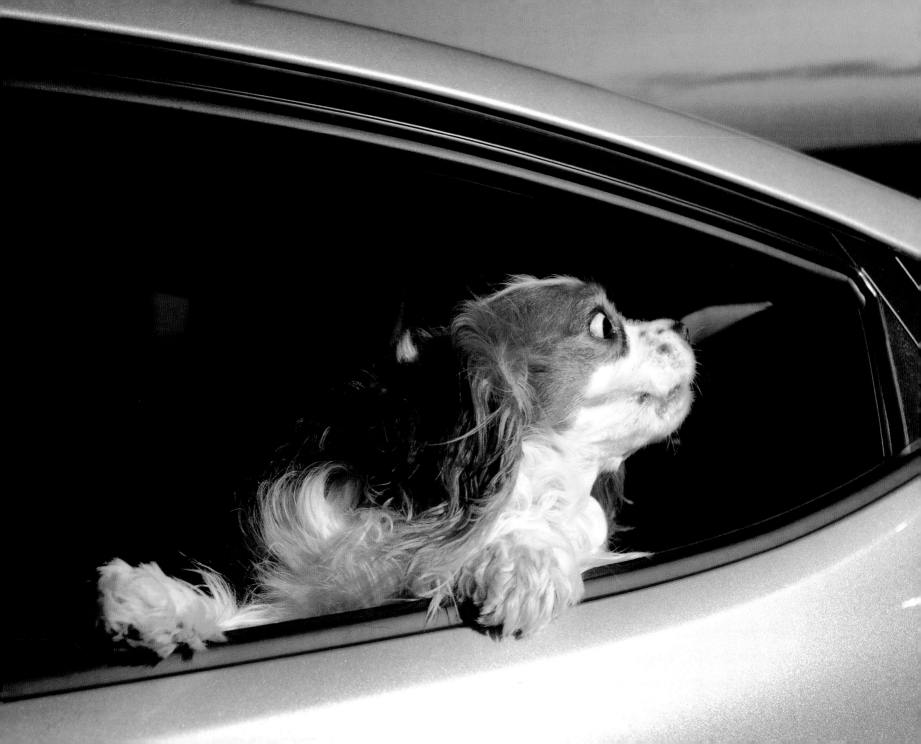

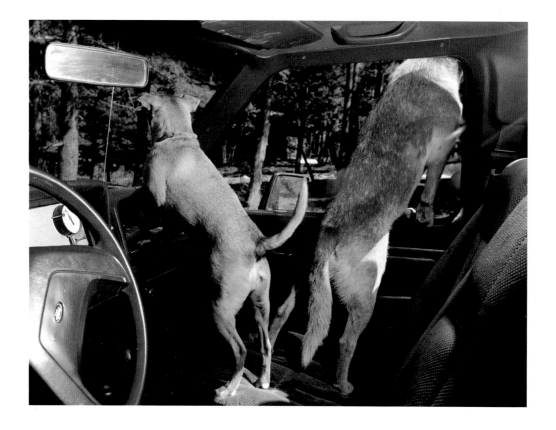

TWYLA & BLU *Jack Russell-Chihuahua Mix & Queensland Heeler*

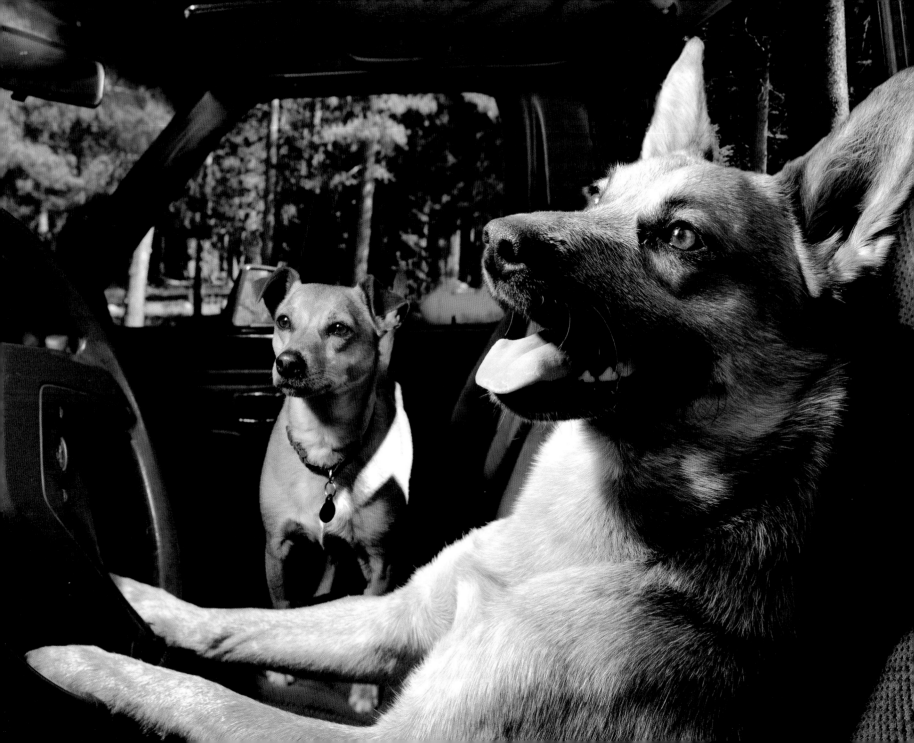

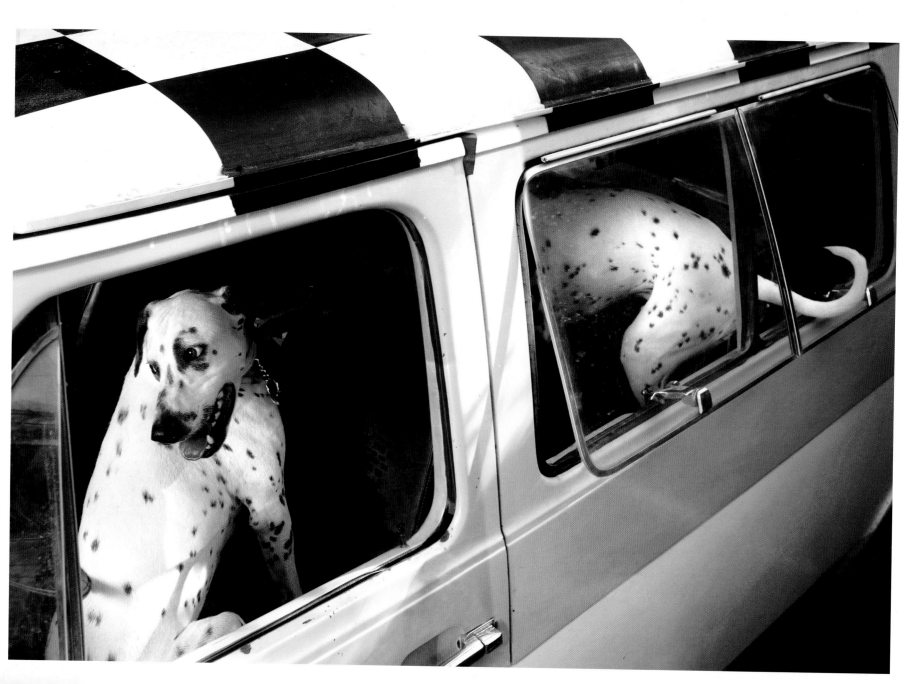

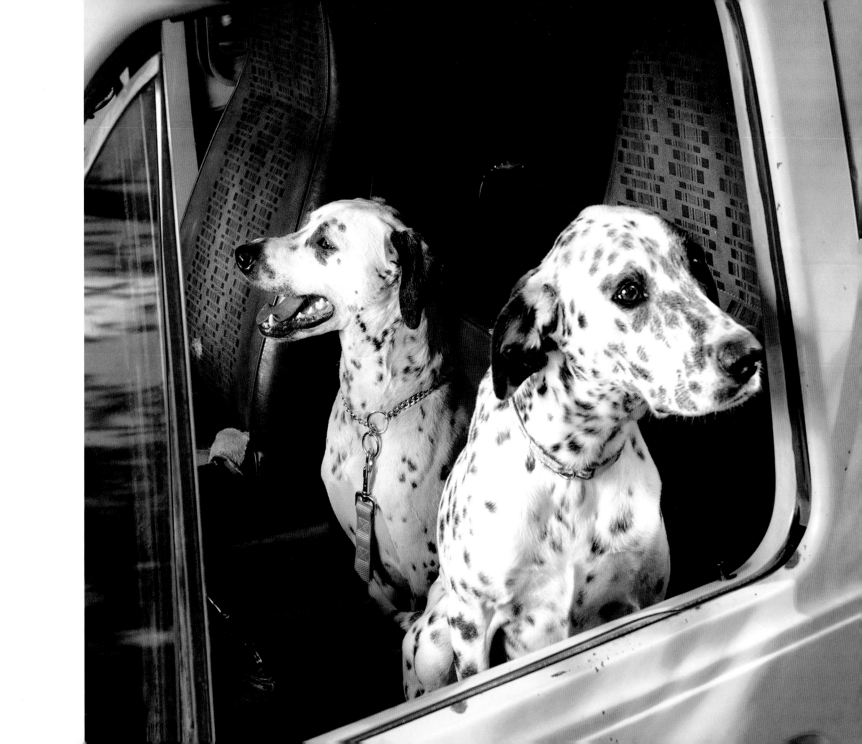

TATUM *Wirehaired Ibizan Hound*

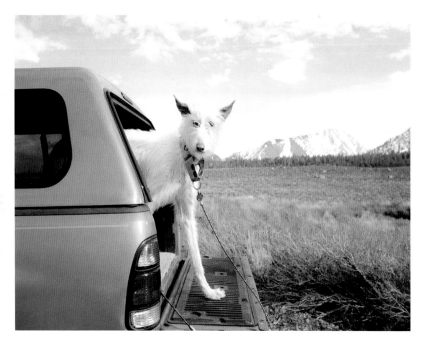

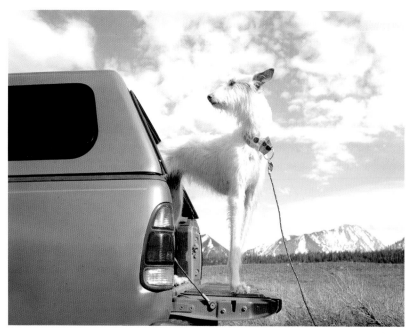

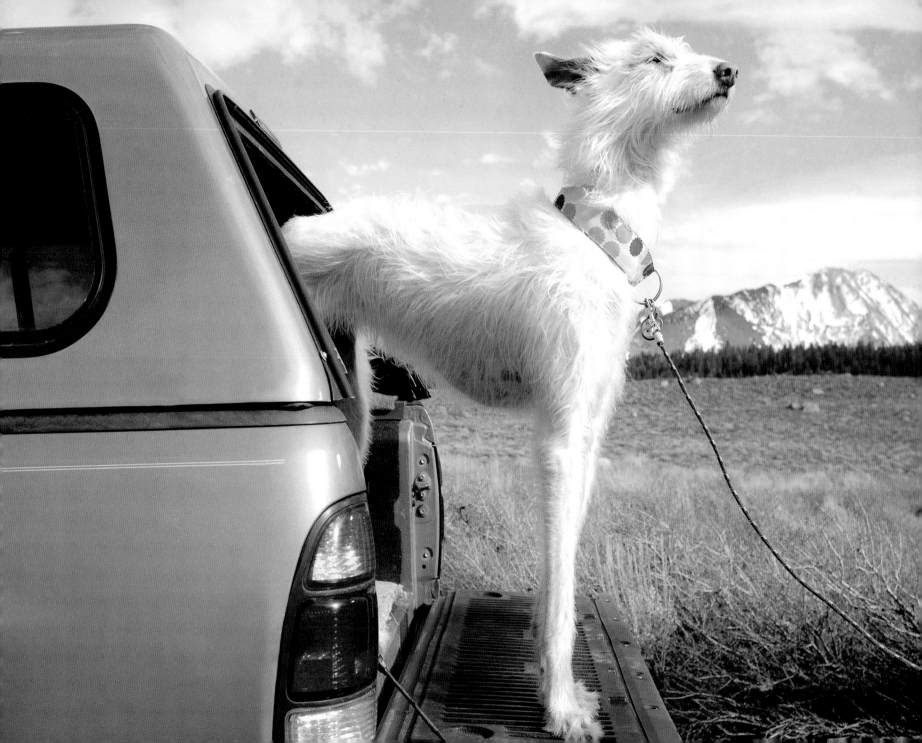

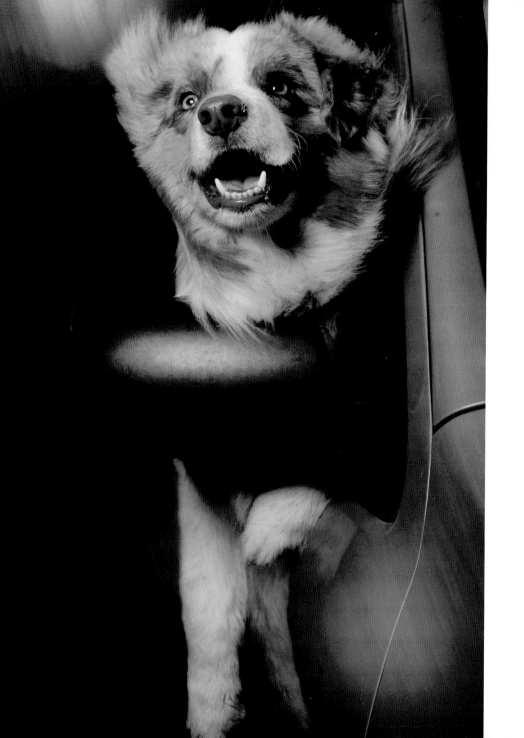

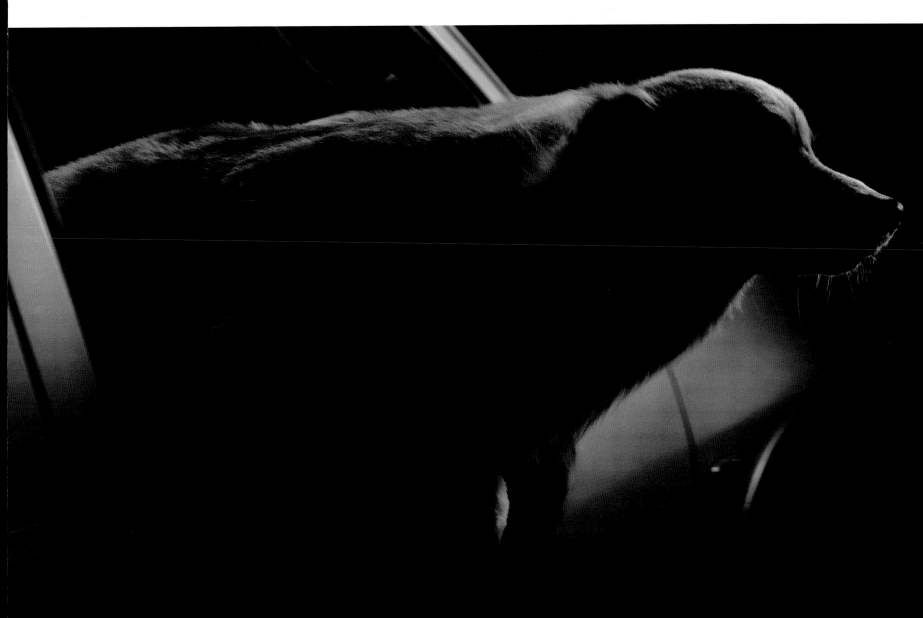

SKID *Australian Shepherd*

INDY, BRODIE & JACK *Australian Shepherds and their point of view*

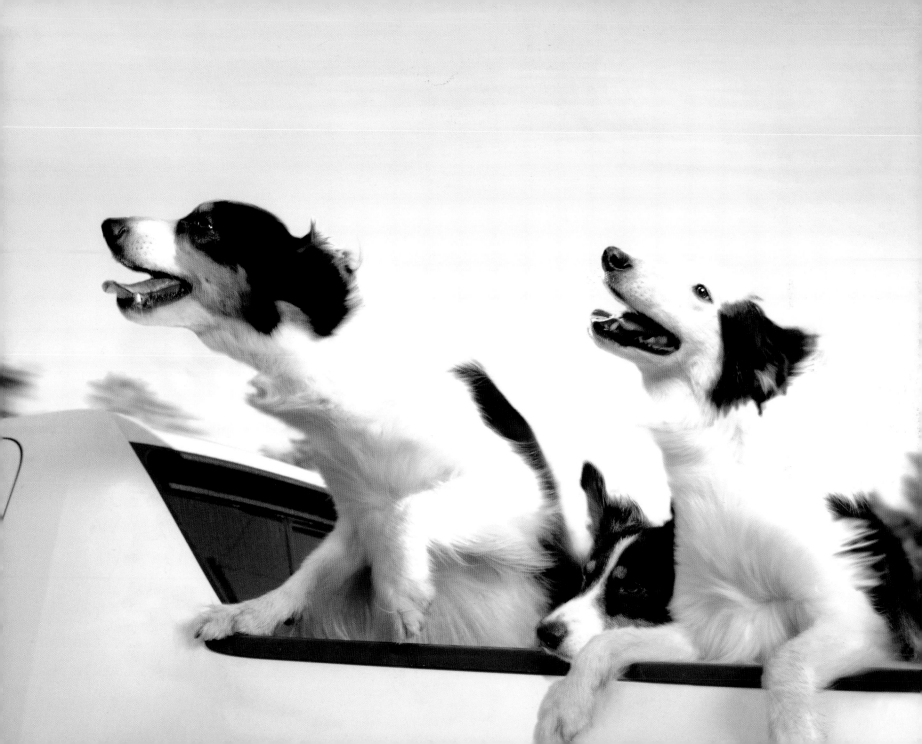

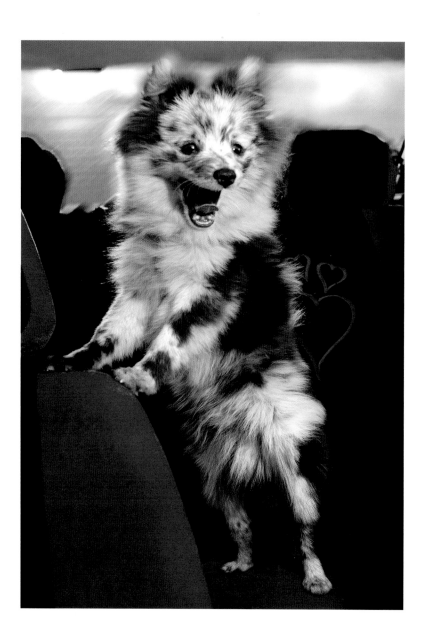

SONIC *Silver Merle Pomeranian*

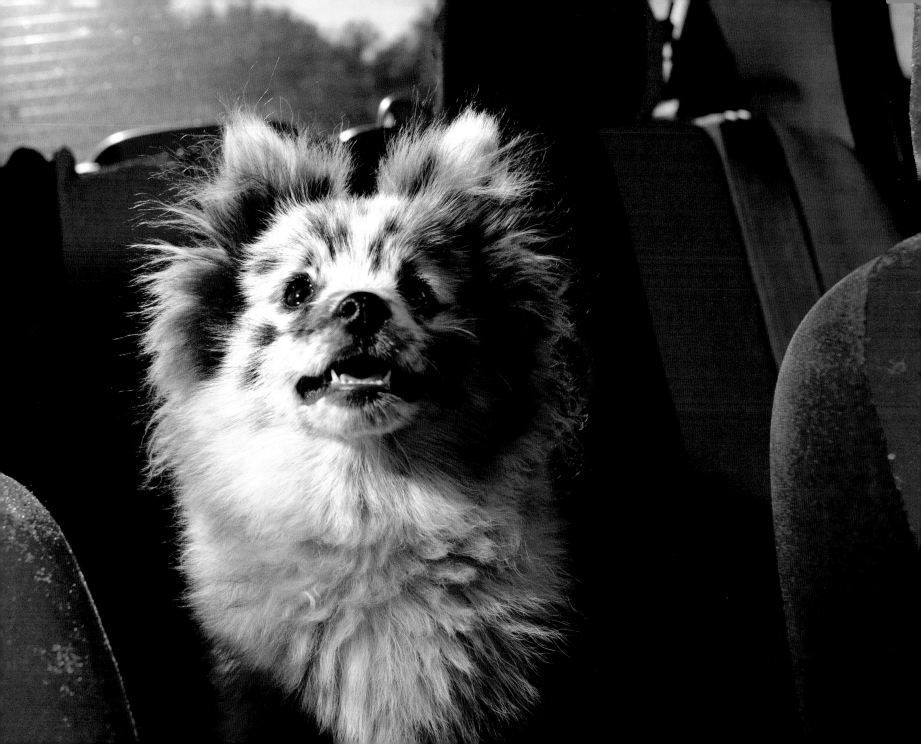

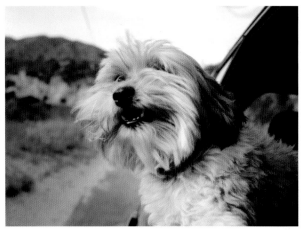

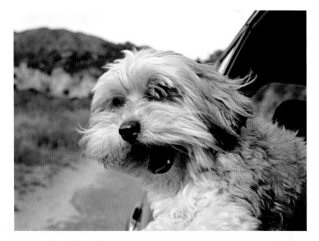

MARS *Lhasa Apso-Poodle Mix*

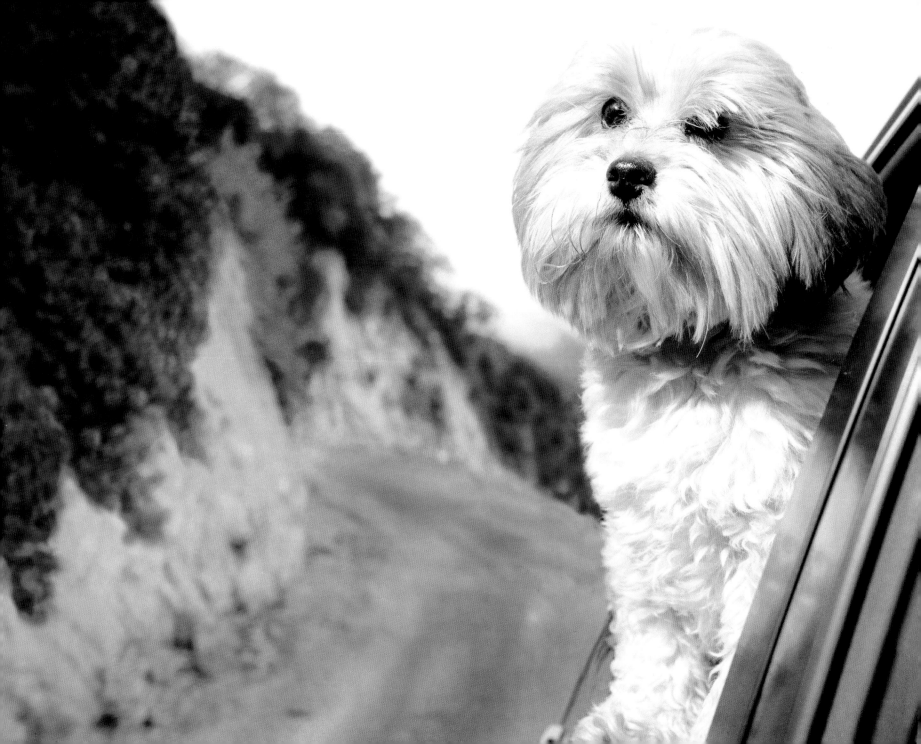

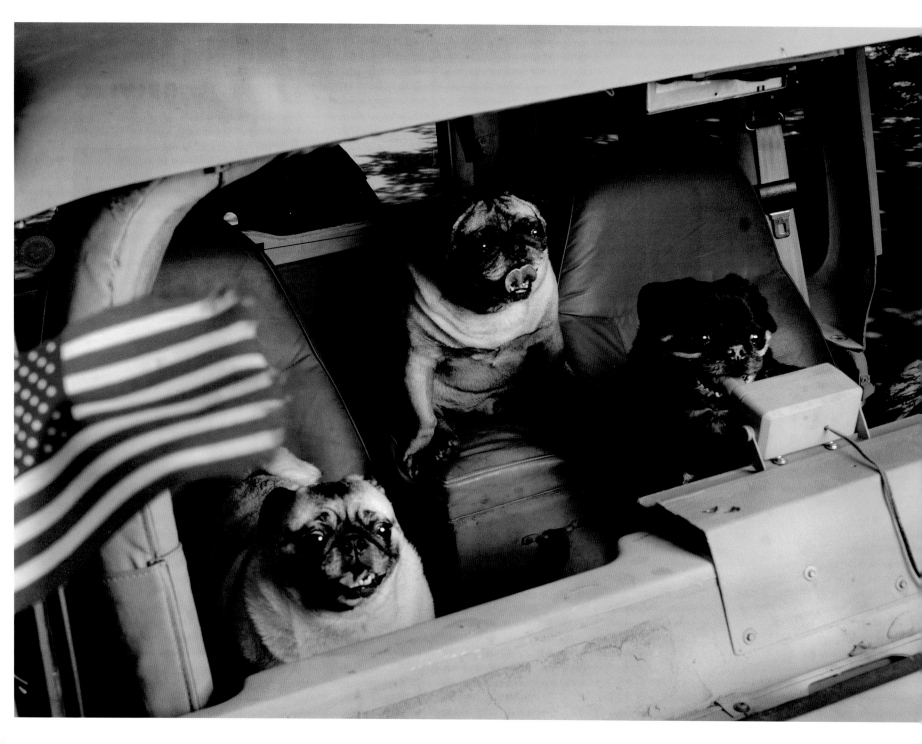

NAPOLEON, LULU & STITCH *Pugs*

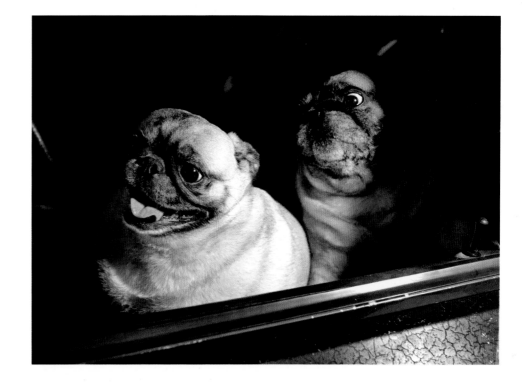

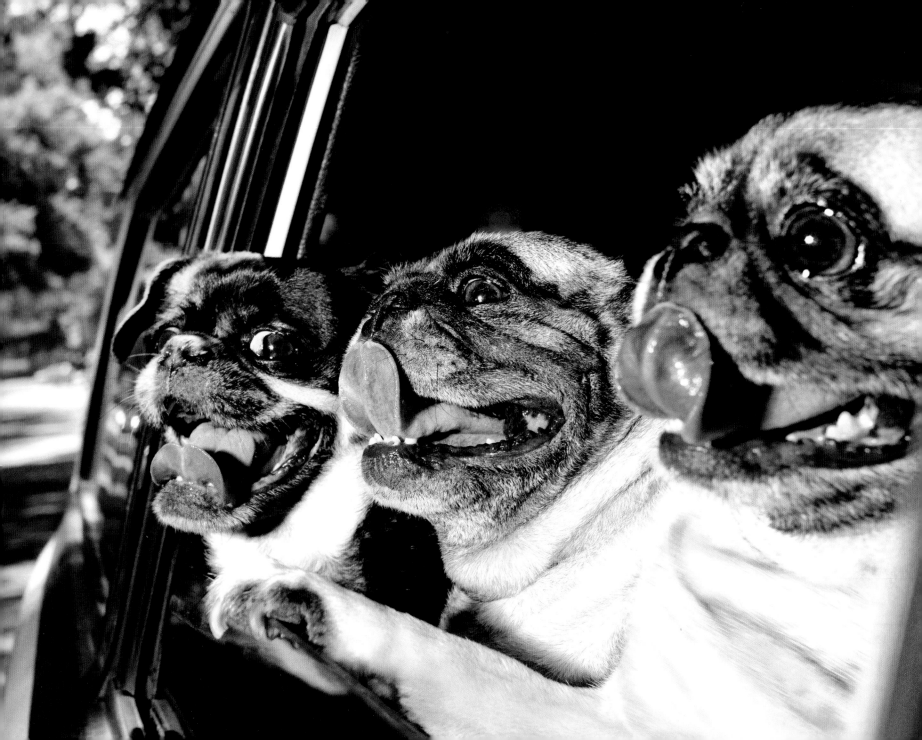

FLOYD *Maltese-Havanese Mix*

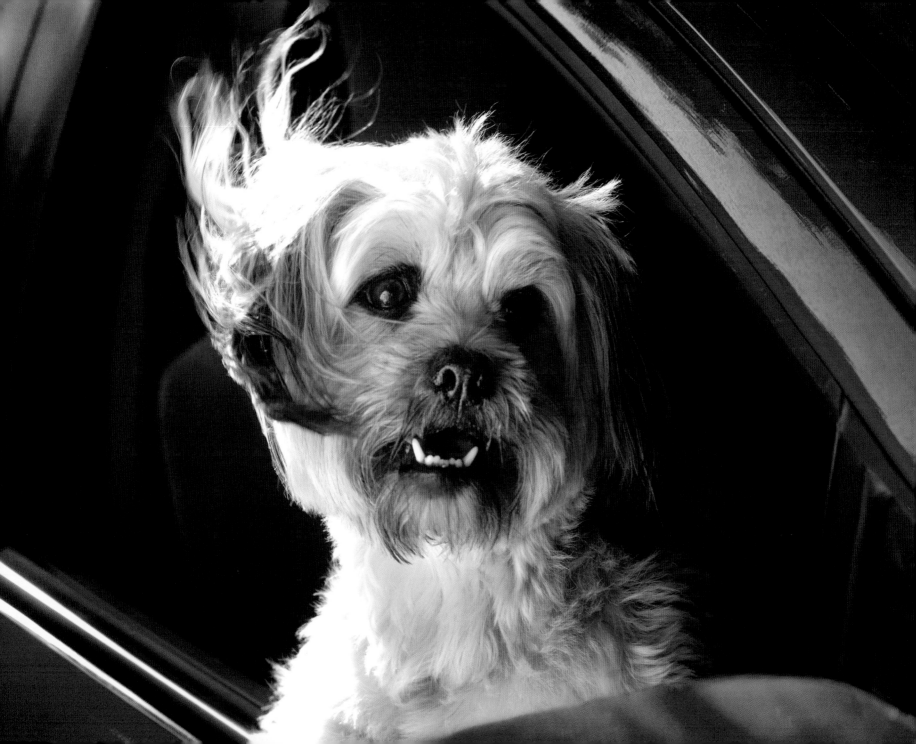

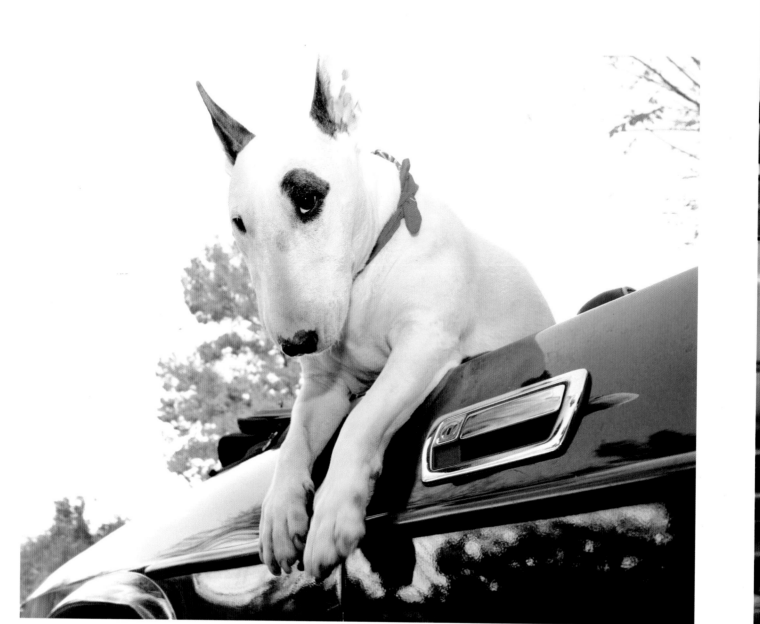

DUGAN *English Bull Terrier*

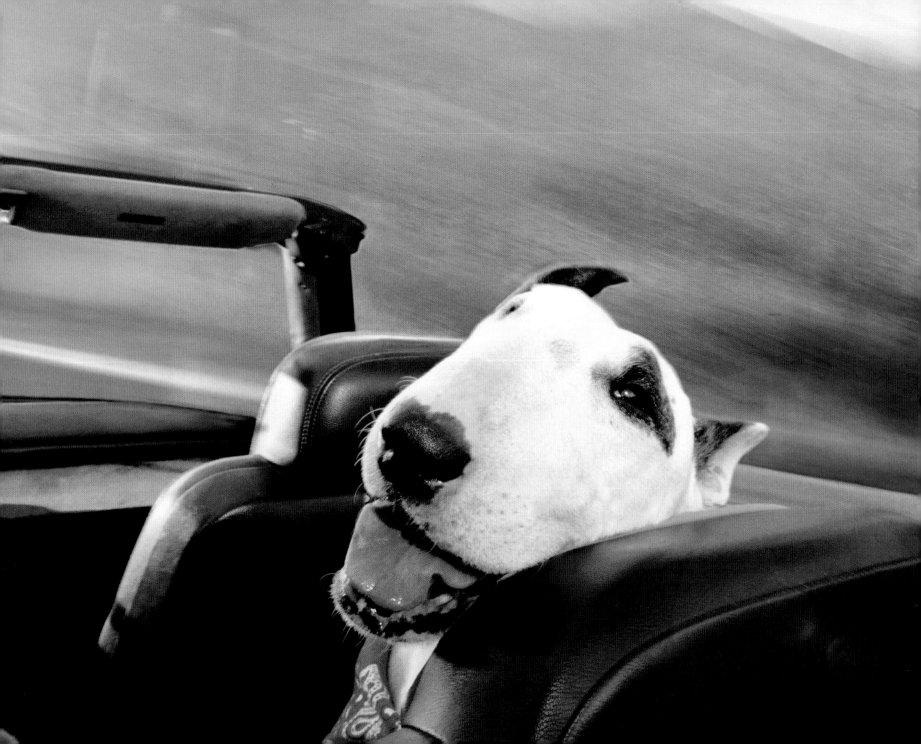

COUNT NUTSFORD *Lab Mix*

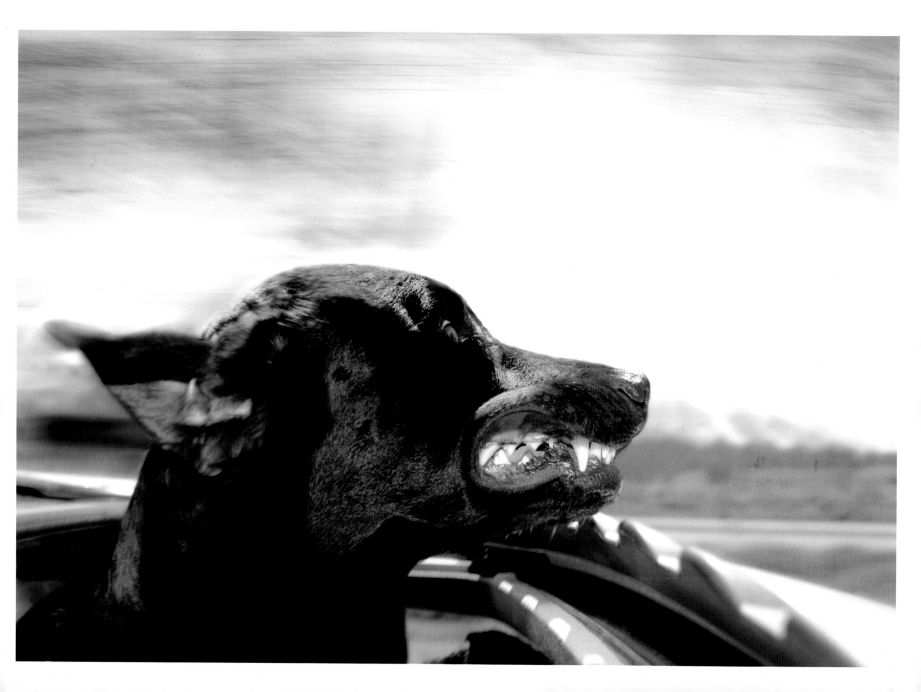

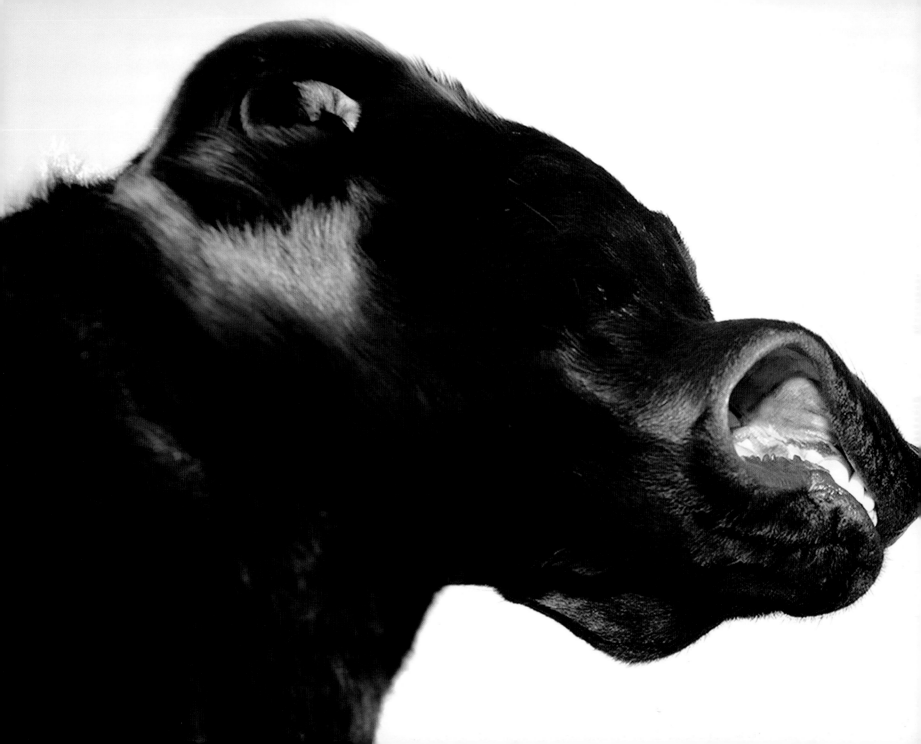

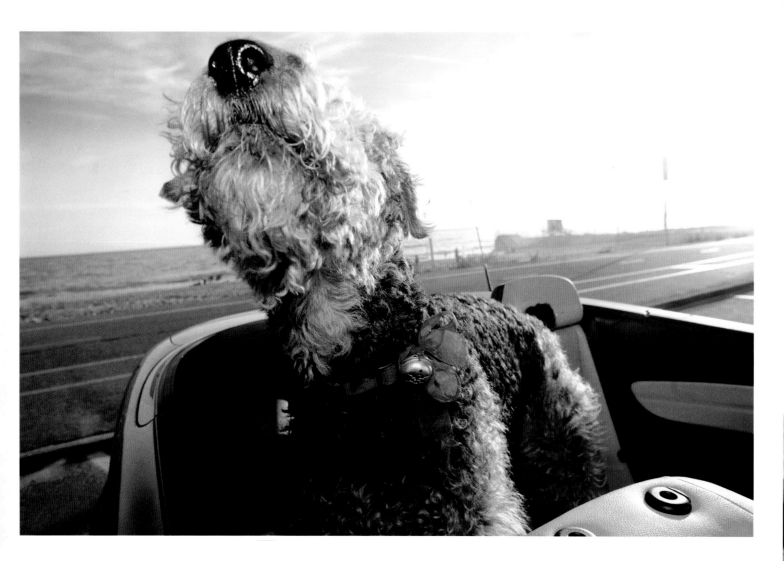

ERNIE *Airedale Terrier*

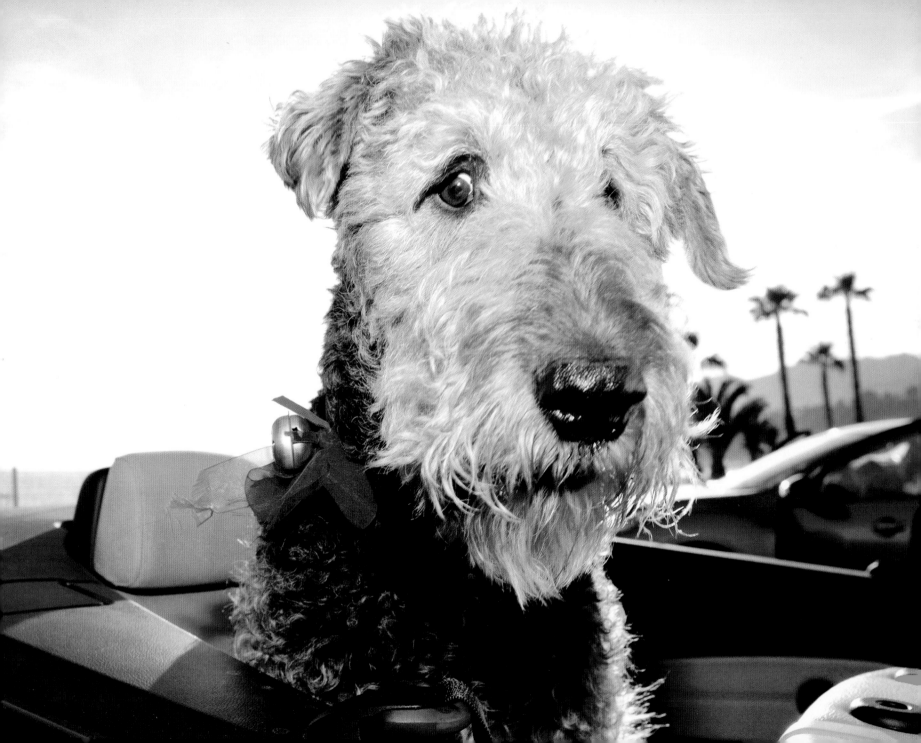

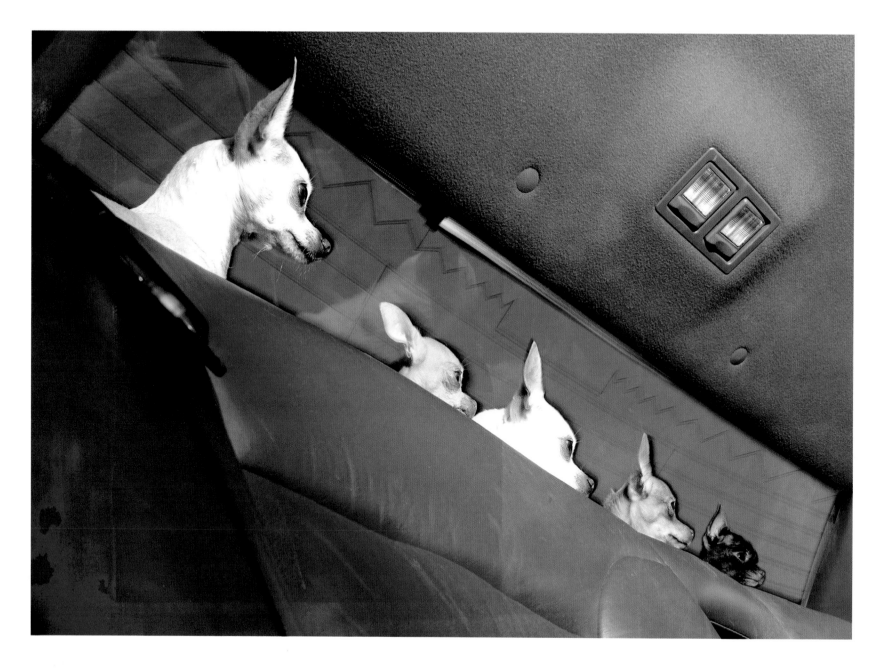

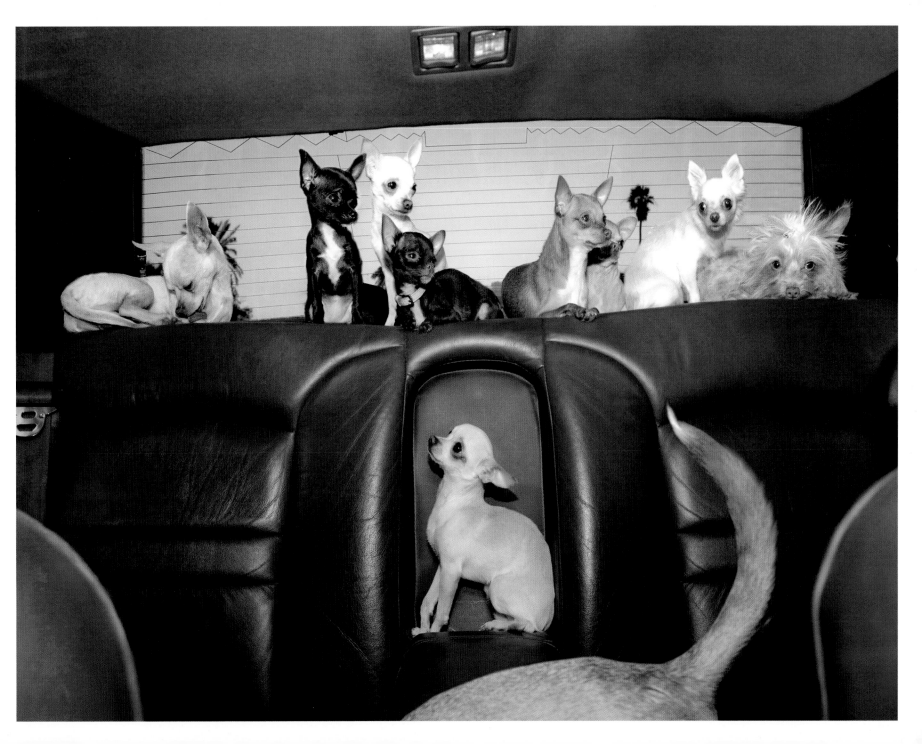

BEAR *Chow-Husky Mix*

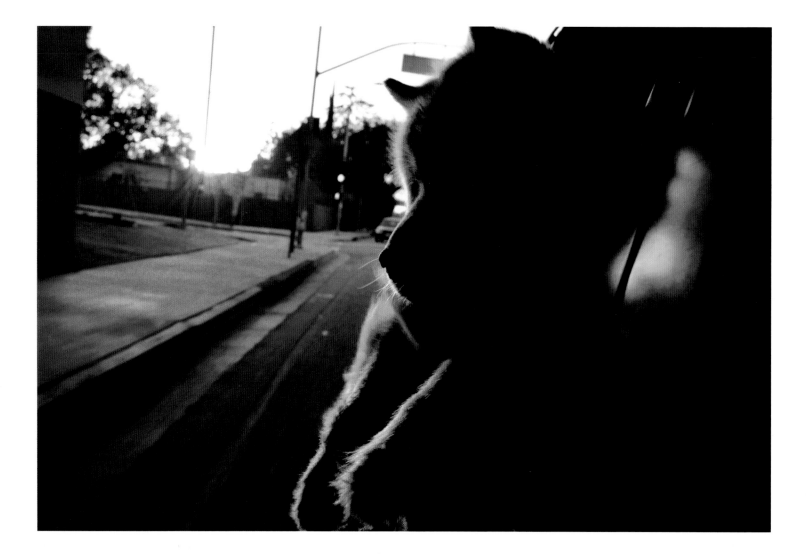

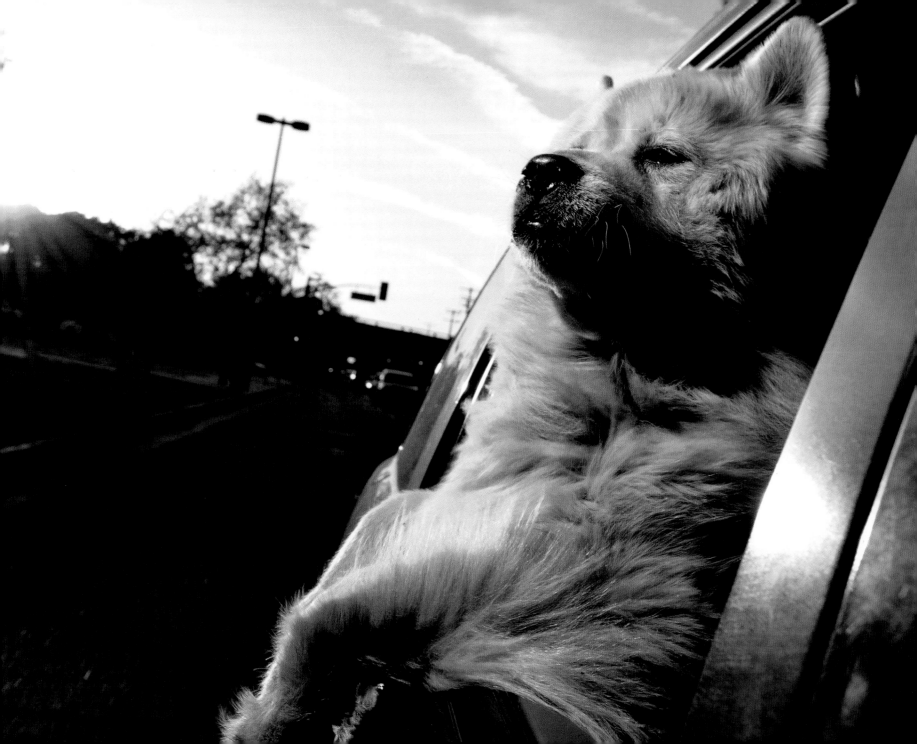

JAKE, LOHTSE & LUCKY *Black Labradors*

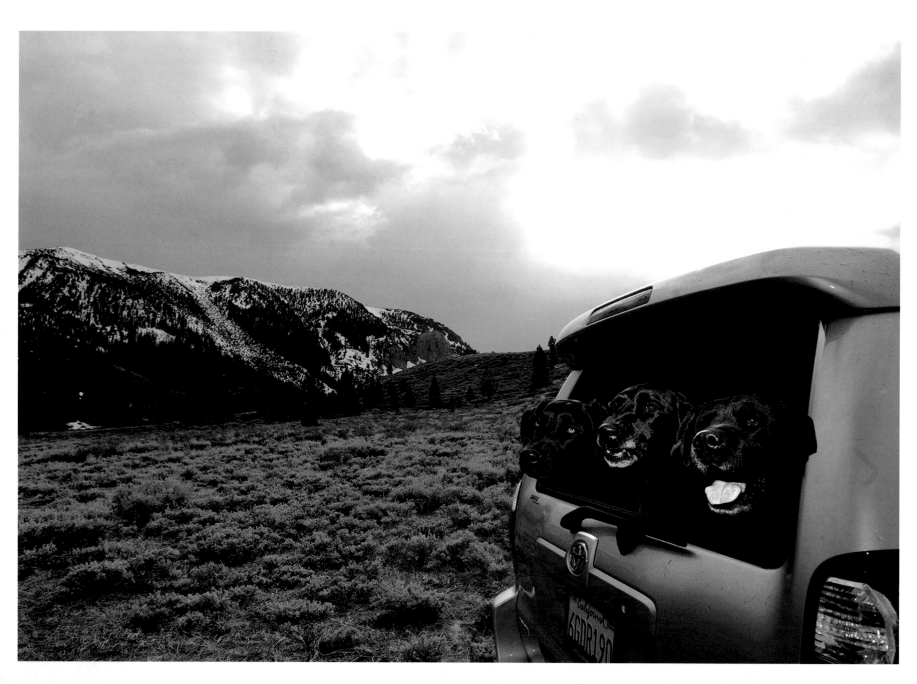

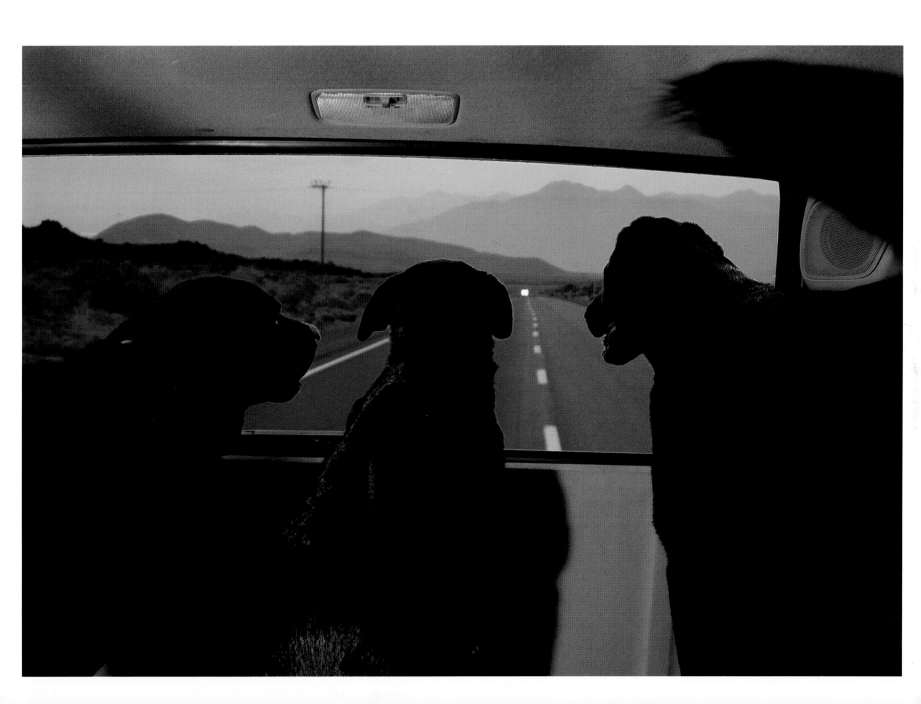

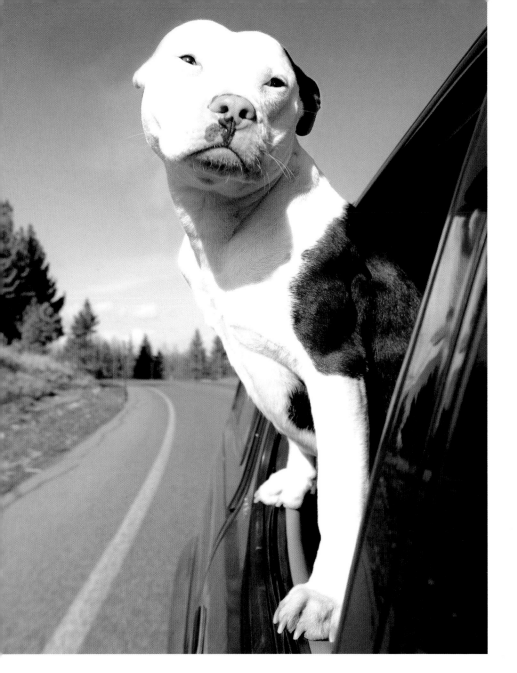

PICKLES *Pit-Staffordshire Mix*

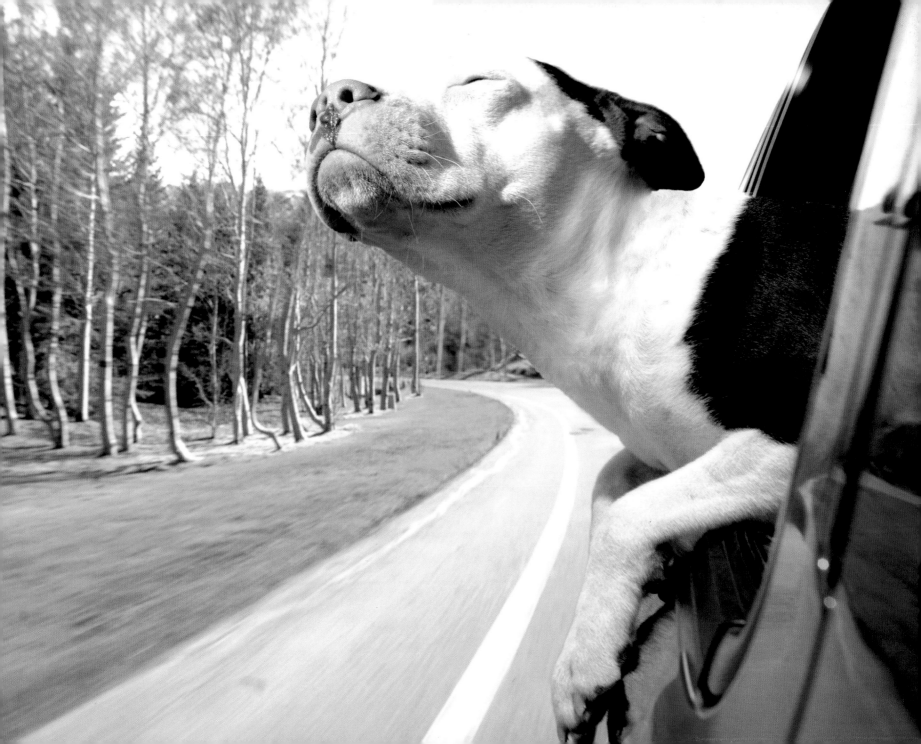

DIEGO *Miniature Schnauzer*

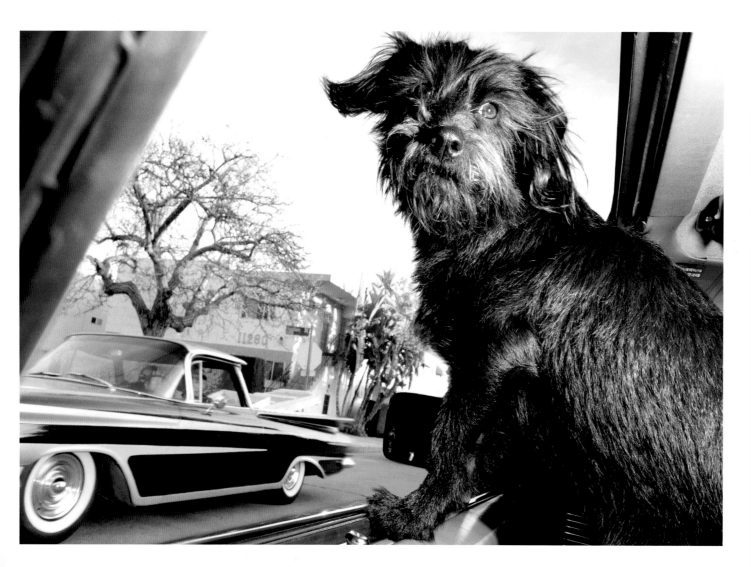

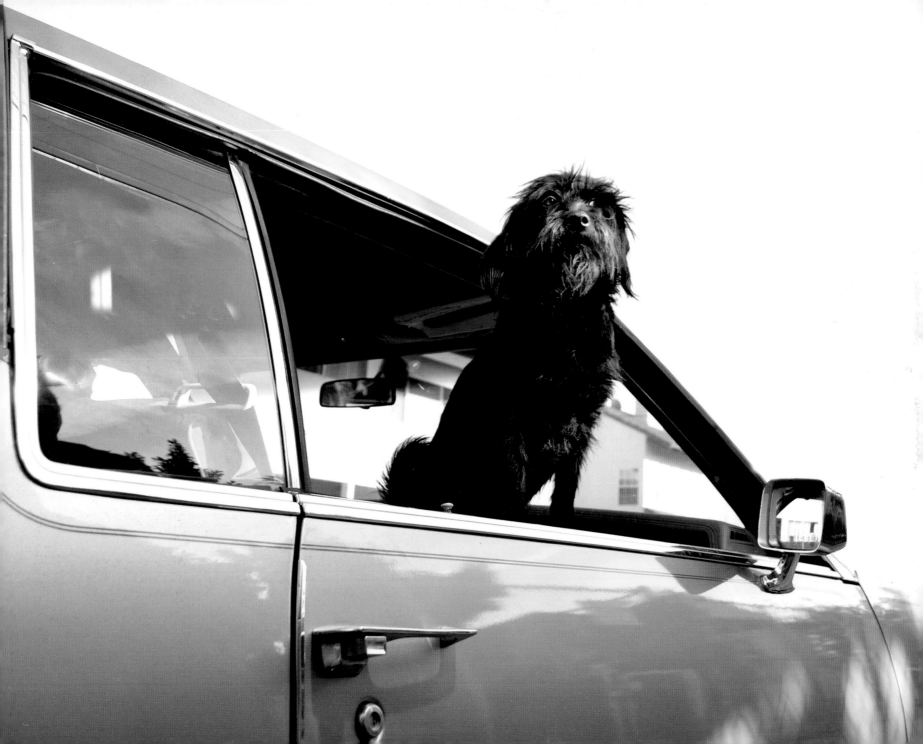

ZIVAN VON DER JANUARI,

AMIRA VON KAZIMOV,

KIRA VON HAUS BURNS,

KAYOS VON HAUS BURNS,

SIERA VON HAUS BURNS

& VON PARTY CRASHER

Rottweilers

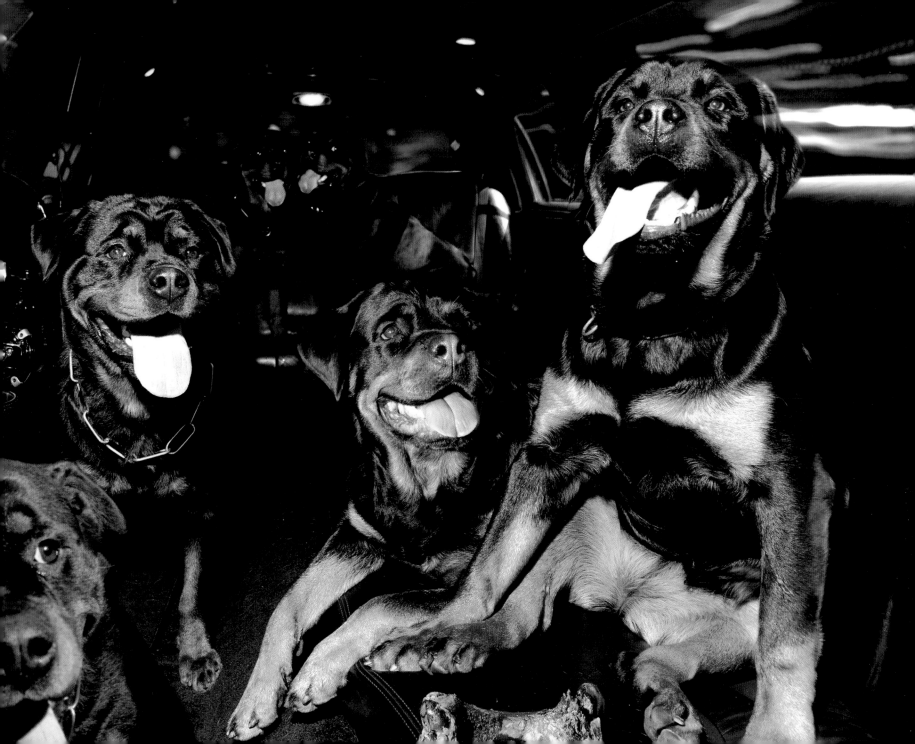

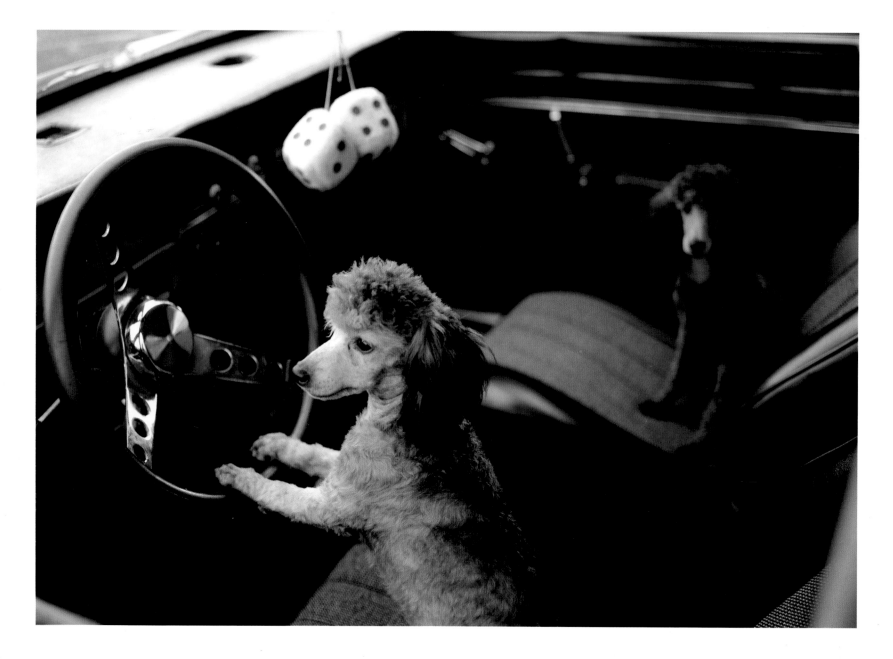

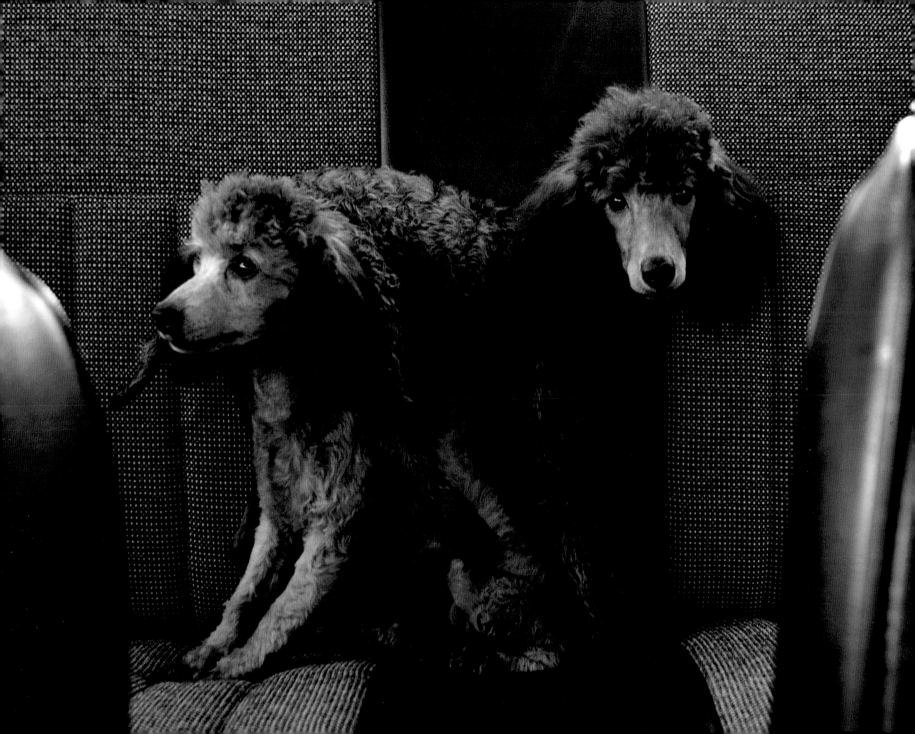

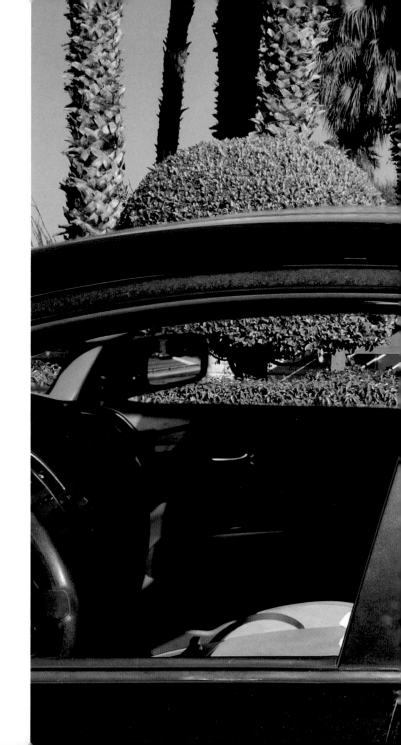

MARLEY *Italian Greyhound*

SASHA *Siberian Husky*

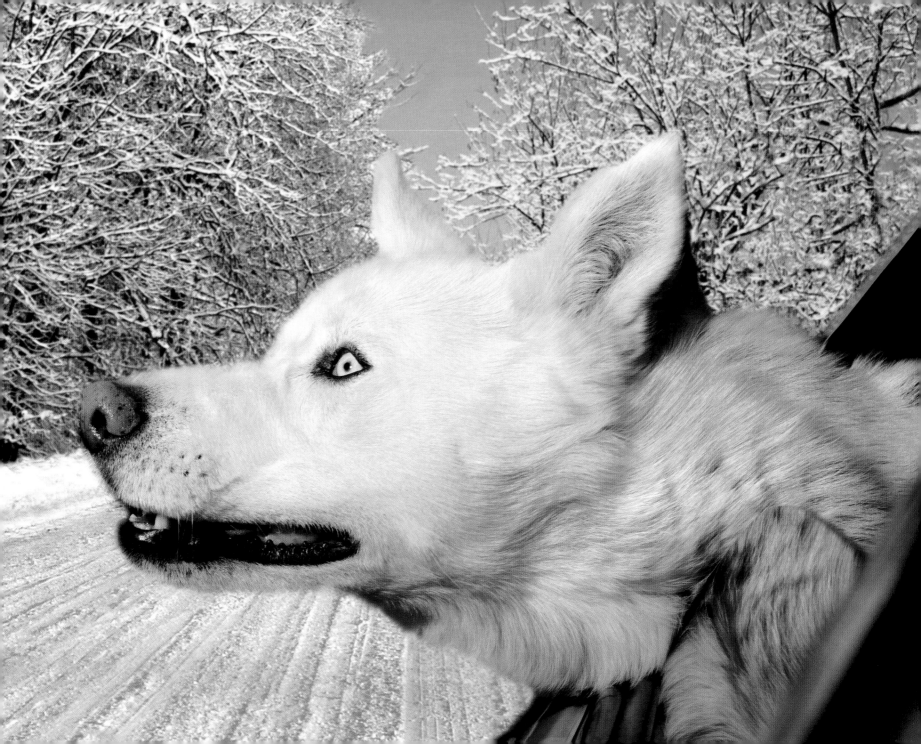

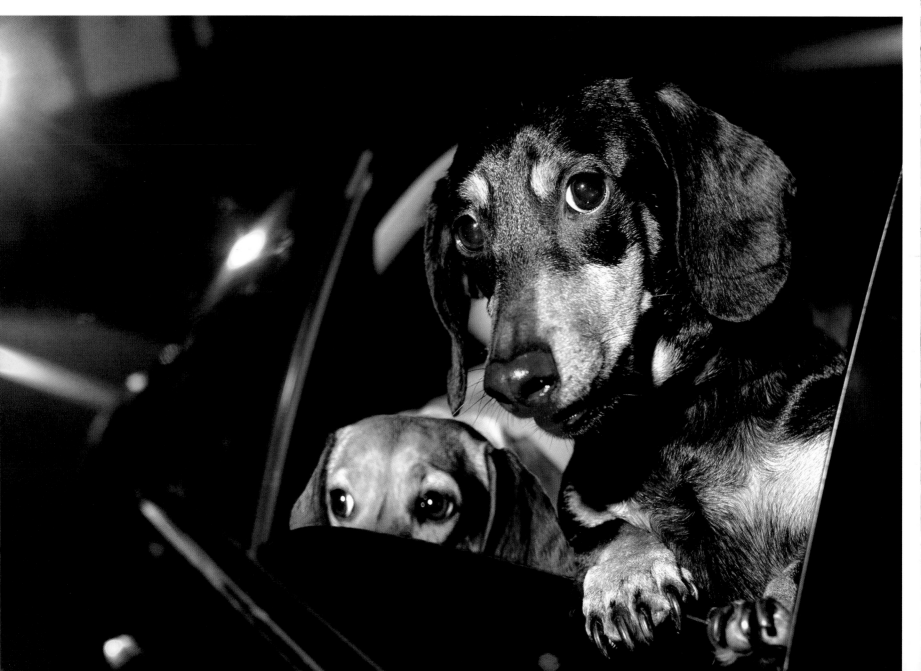

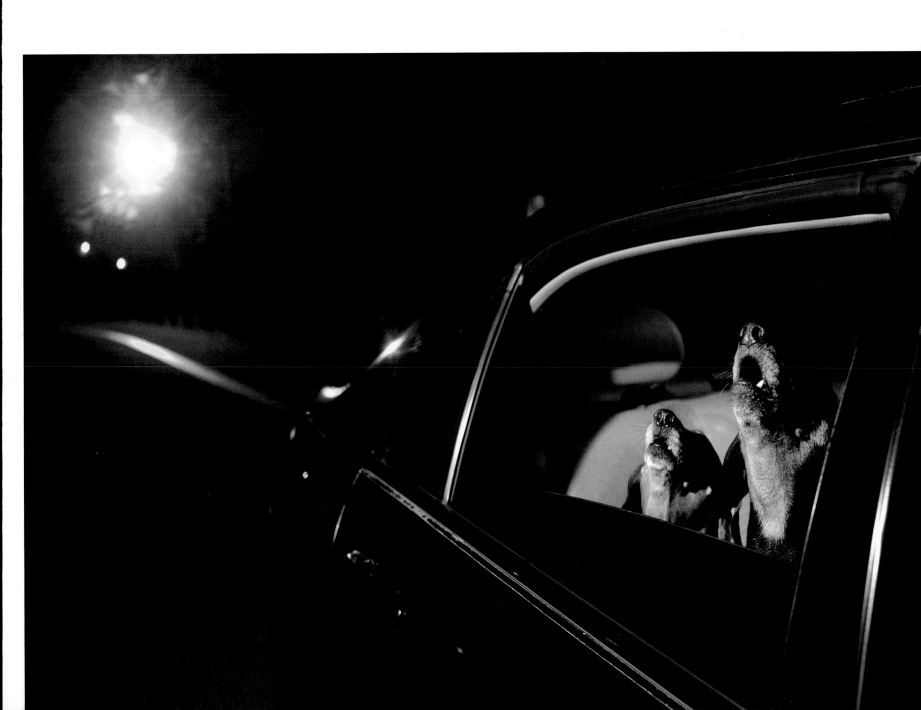

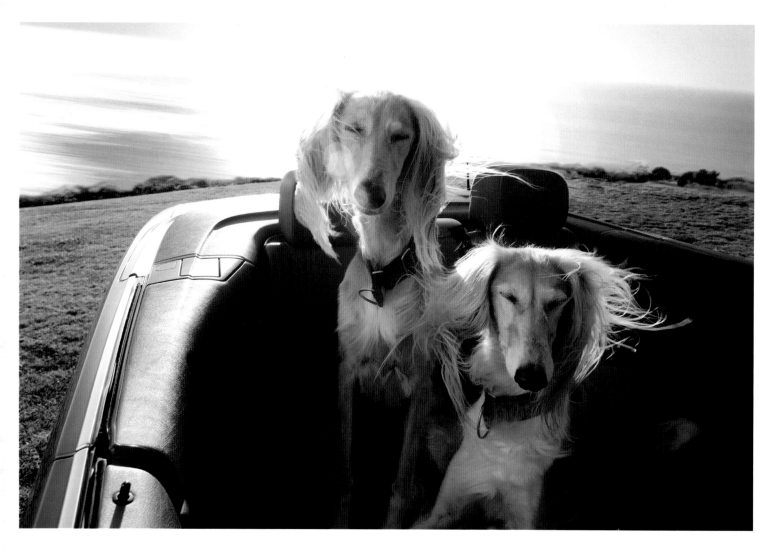
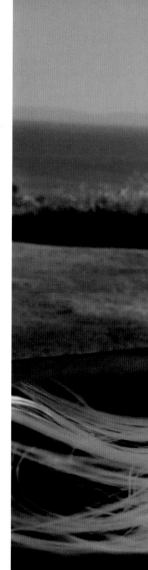

REEM & RASHEED *Salukis*

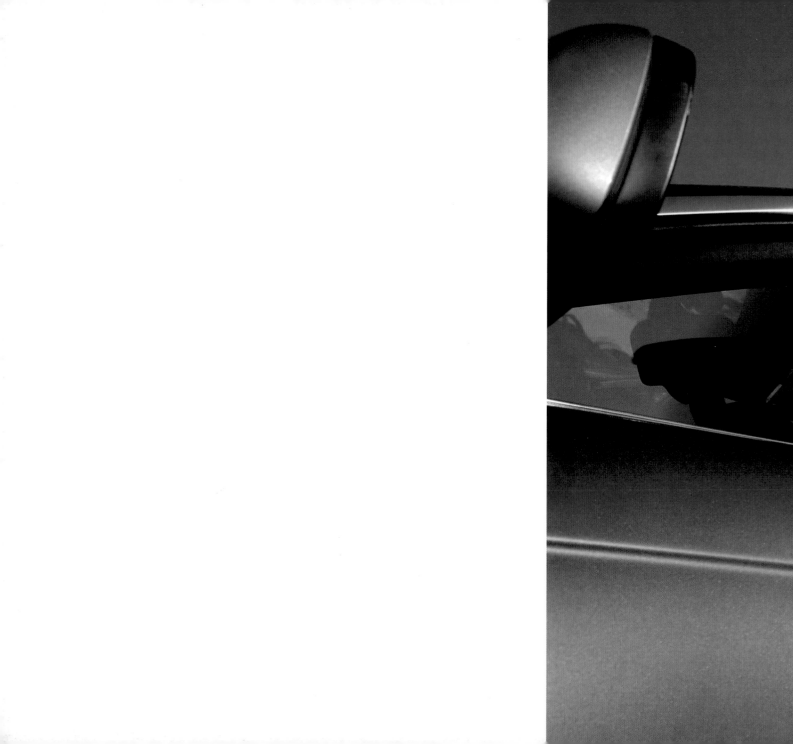

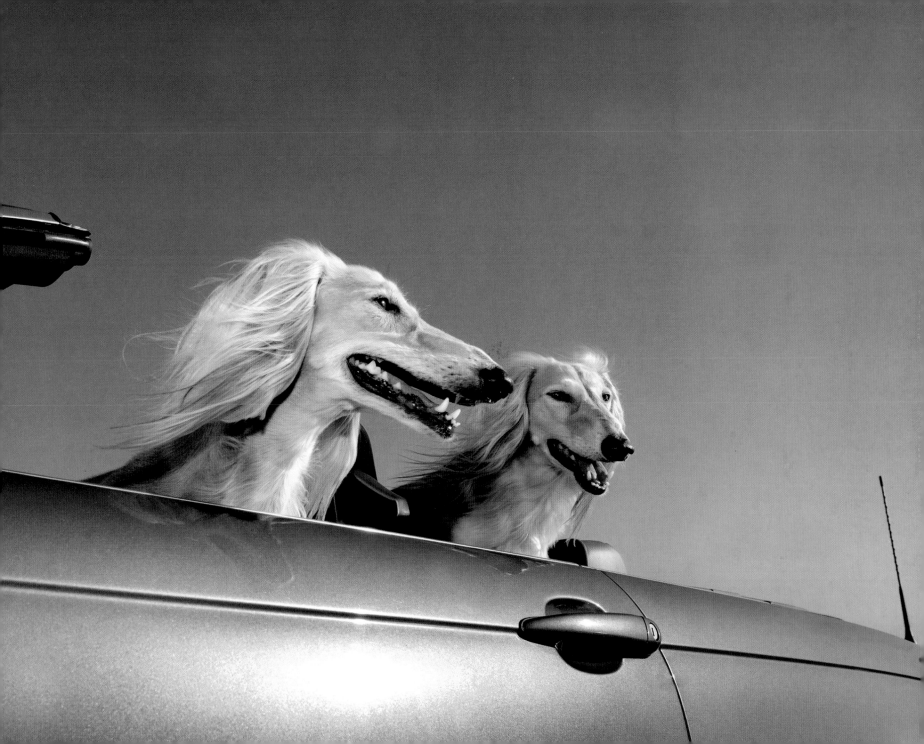

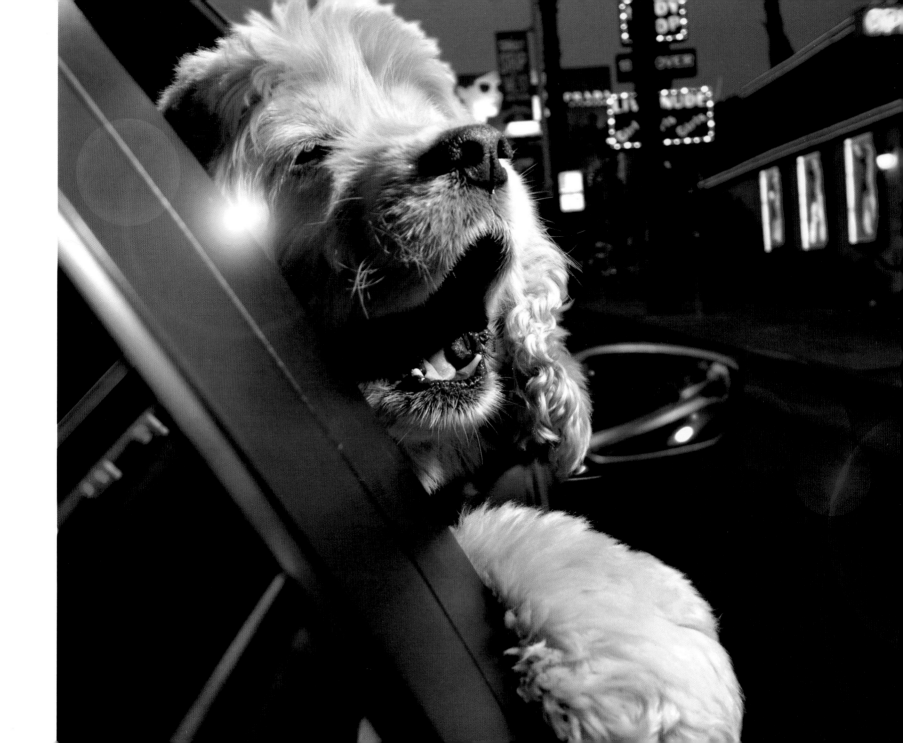

MIKEY *Cocker Spaniel*

MIKEY'S POINT OF VIEW

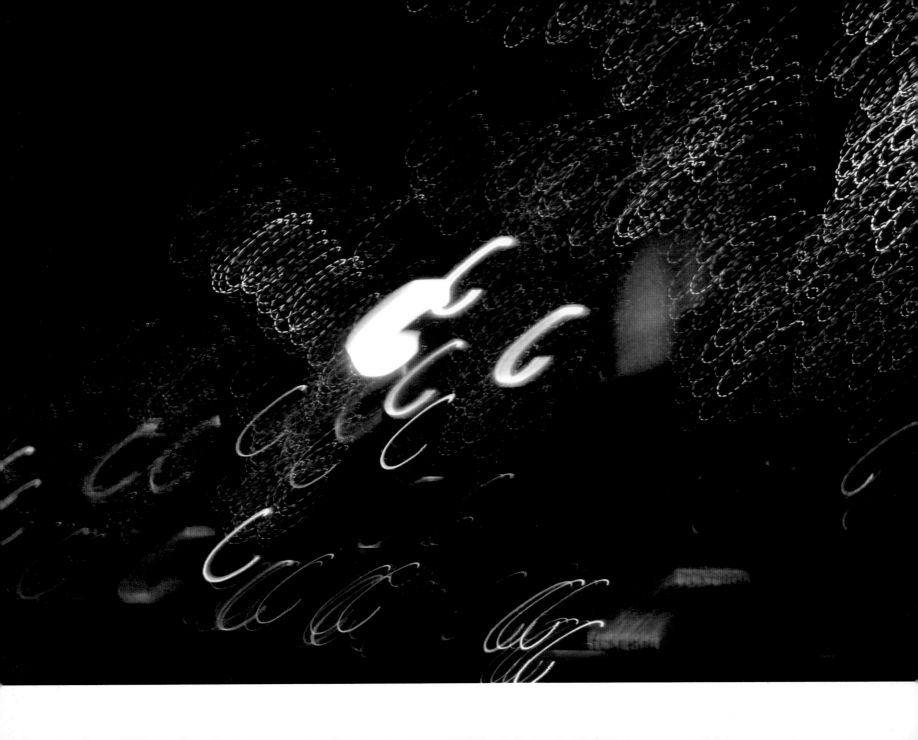

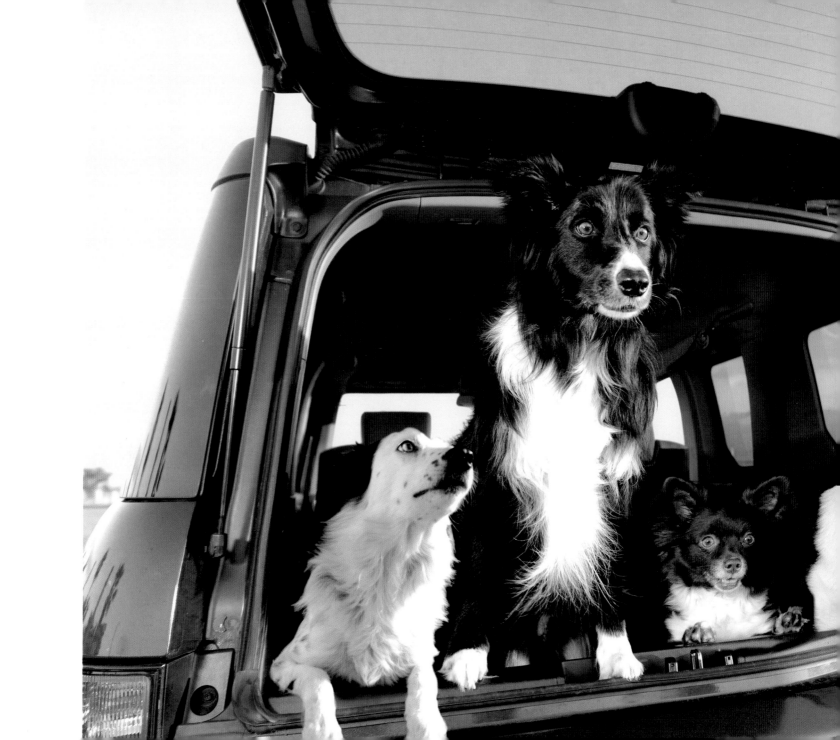

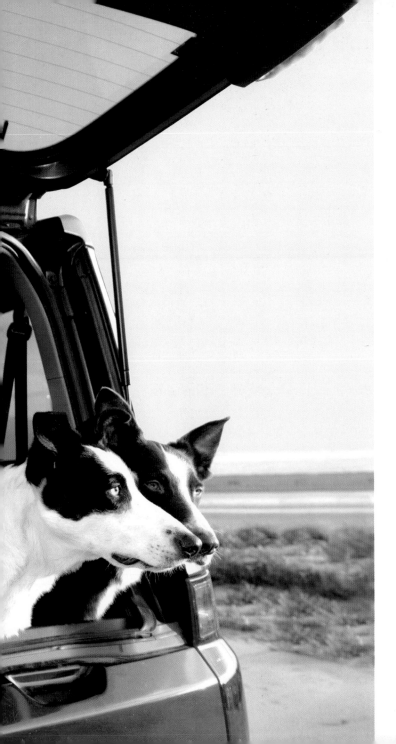

BLITZ *Border Collie*

SKETCH *Border Collie*

EEVEE *Chihuahua Mix*

TORCH *McNab*

FLASH *McNab*

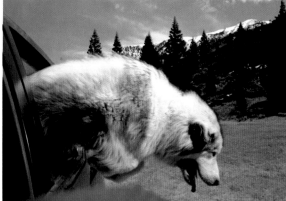

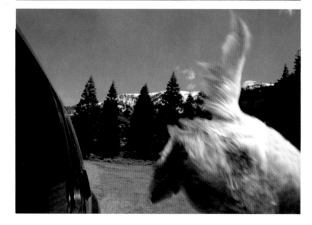

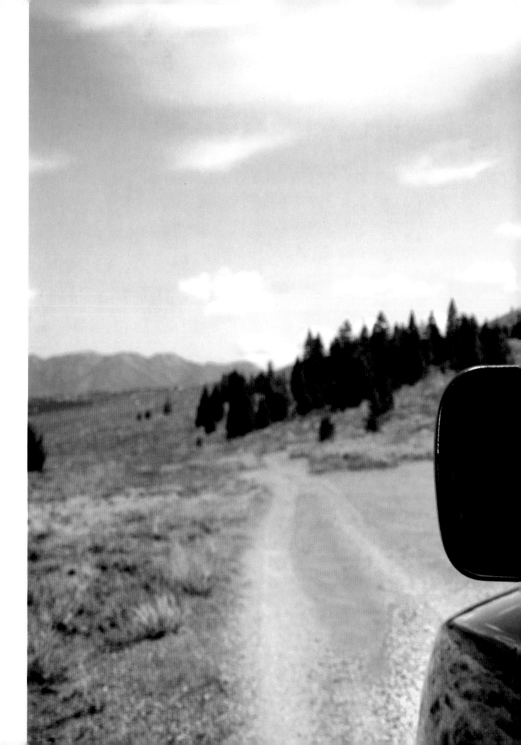

MYSTIC *Great Pyrenees-Alaskan Malamute Mix*

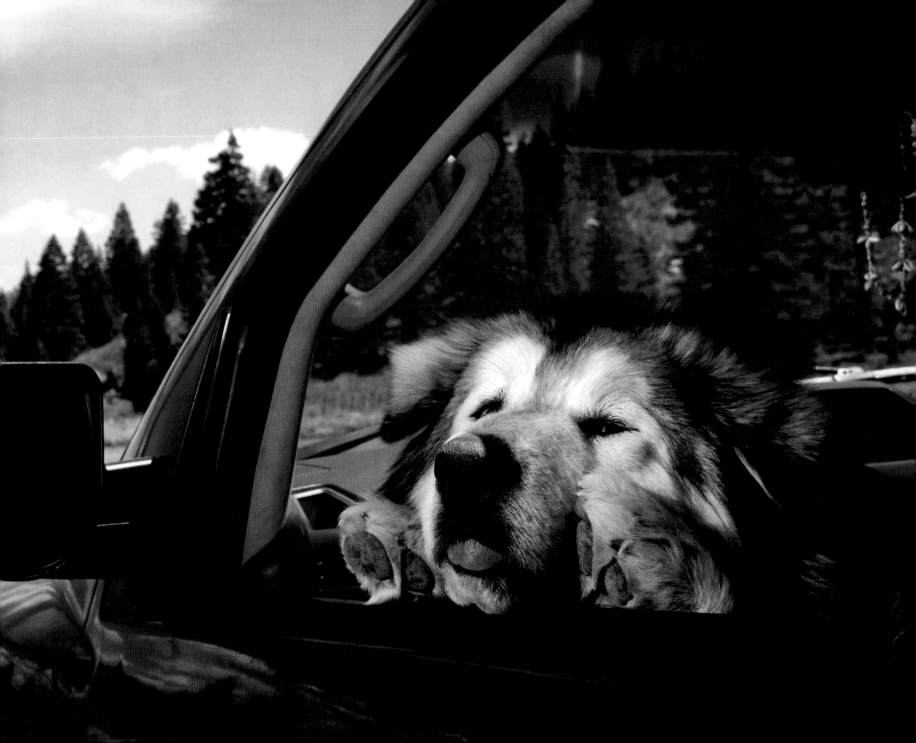

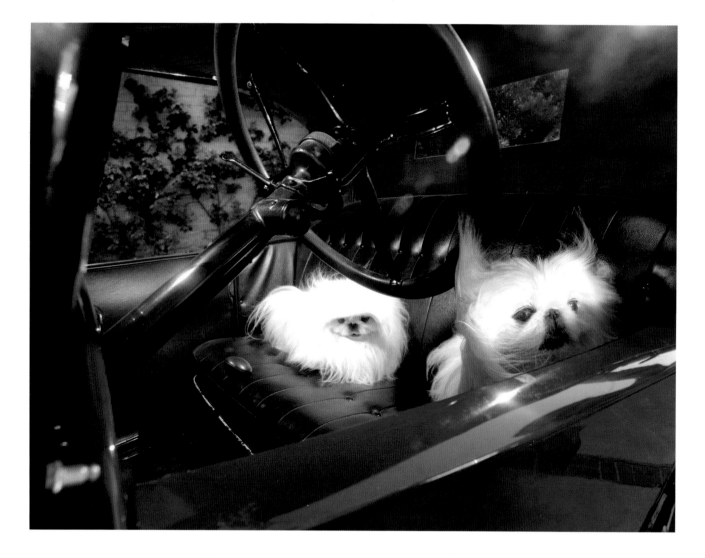

DIVA PEARL & SHOKO MOKO *Pekingese*

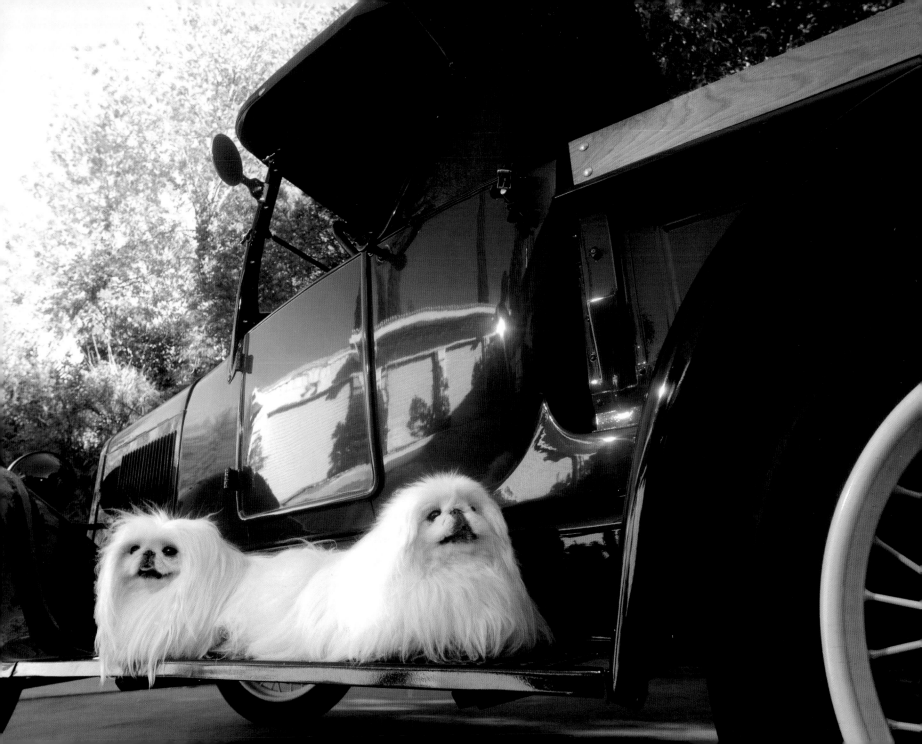

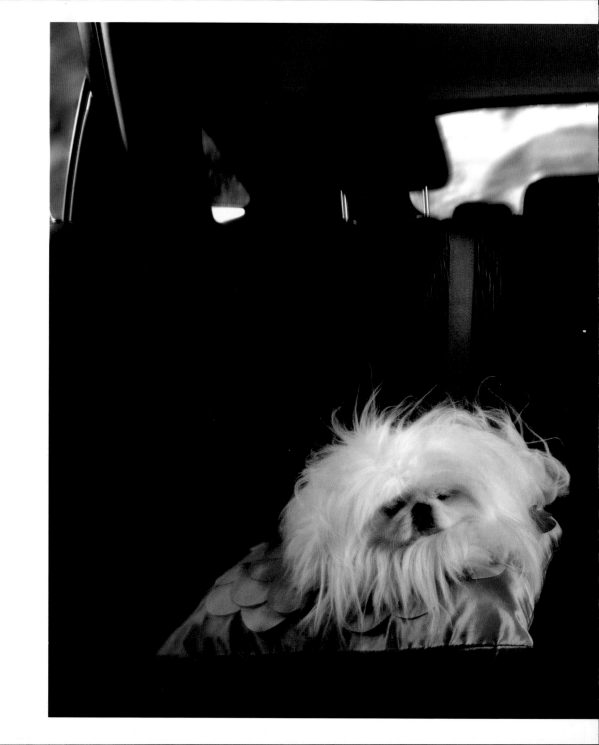

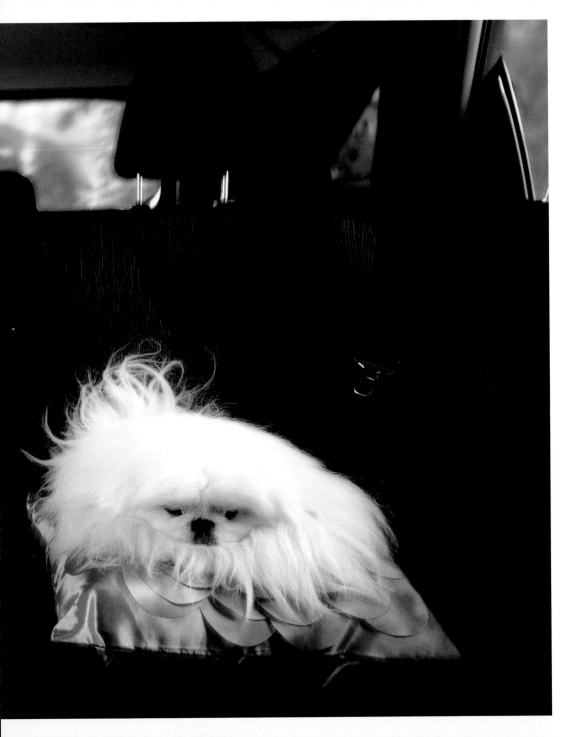

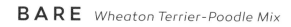

BARE *Wheaton Terrier-Poodle Mix*

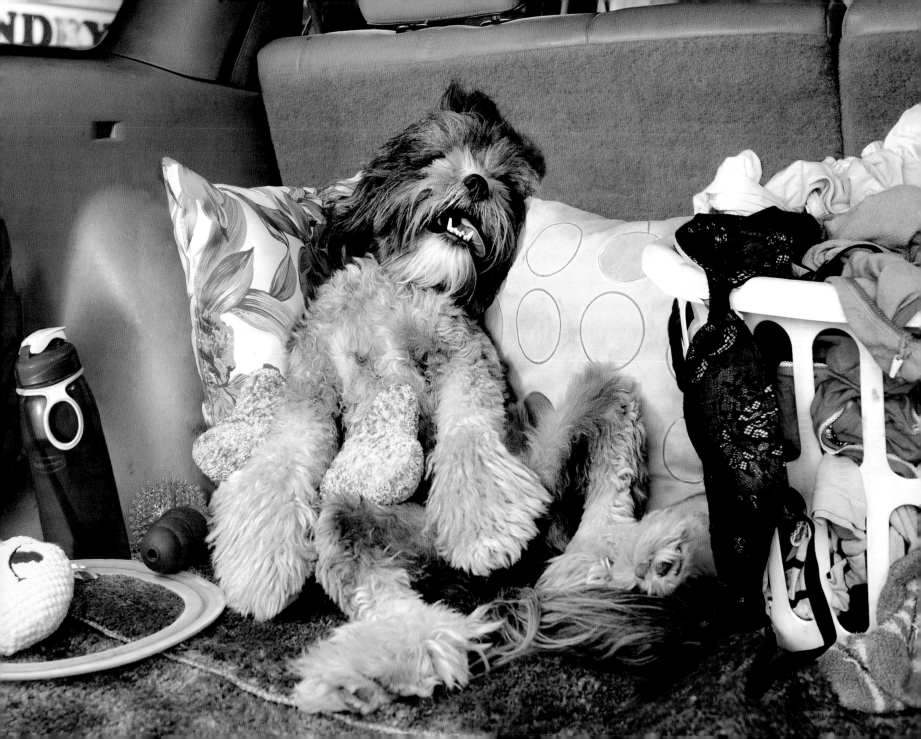

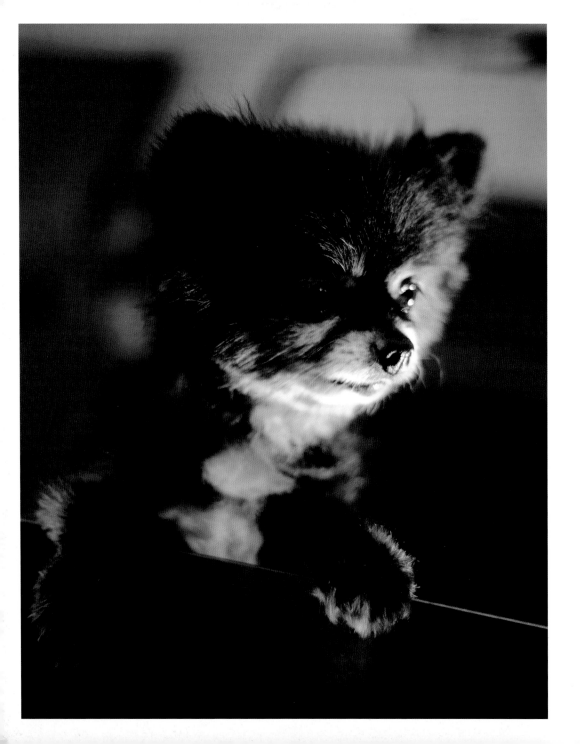

BEARLIE *Toy Pomeranian*

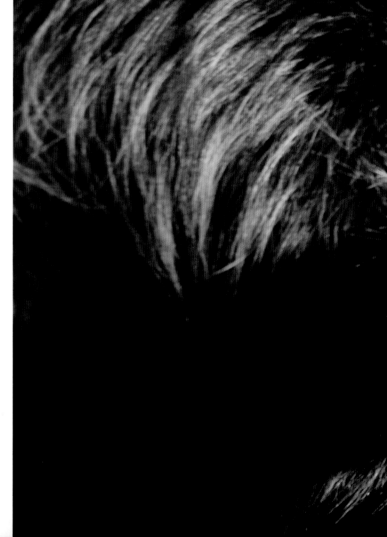

HUCKLEBERRY *Lab-Shepherd Mix*

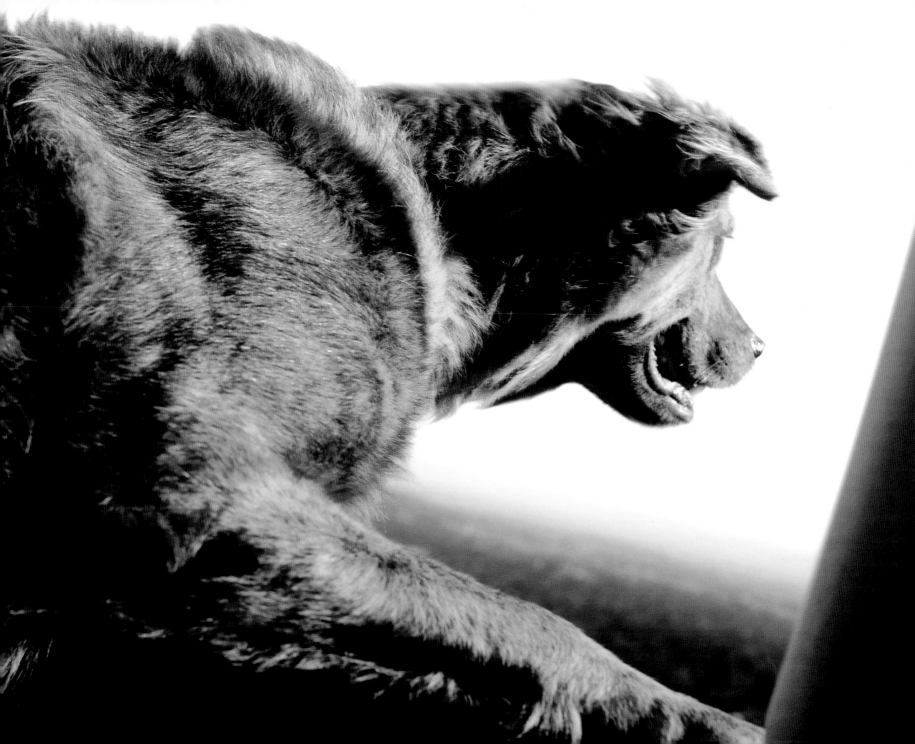

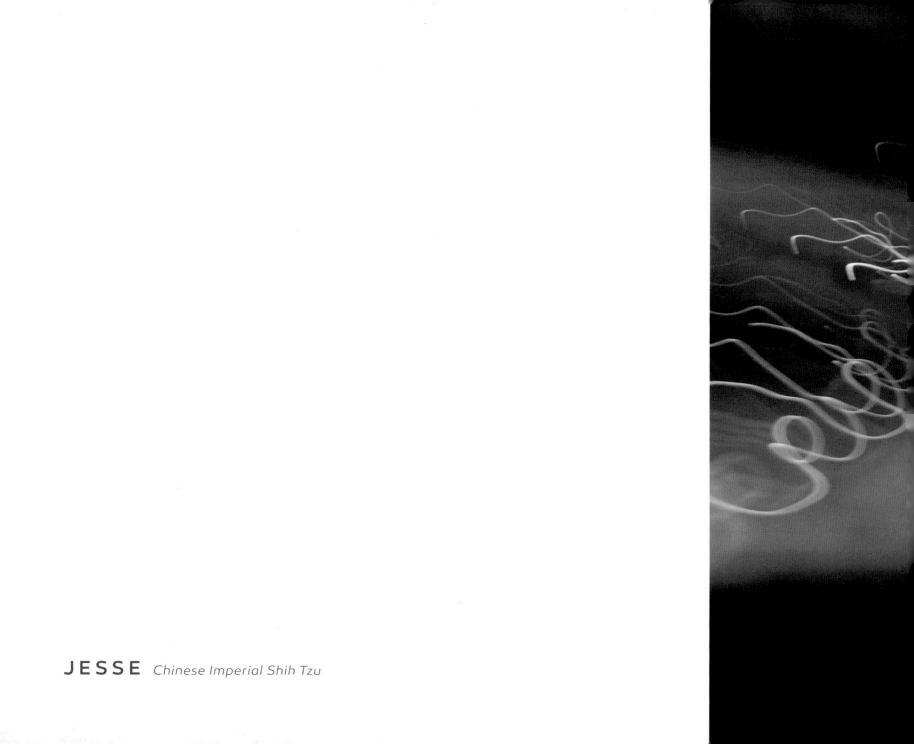

JESSE *Chinese Imperial Shih Tzu*

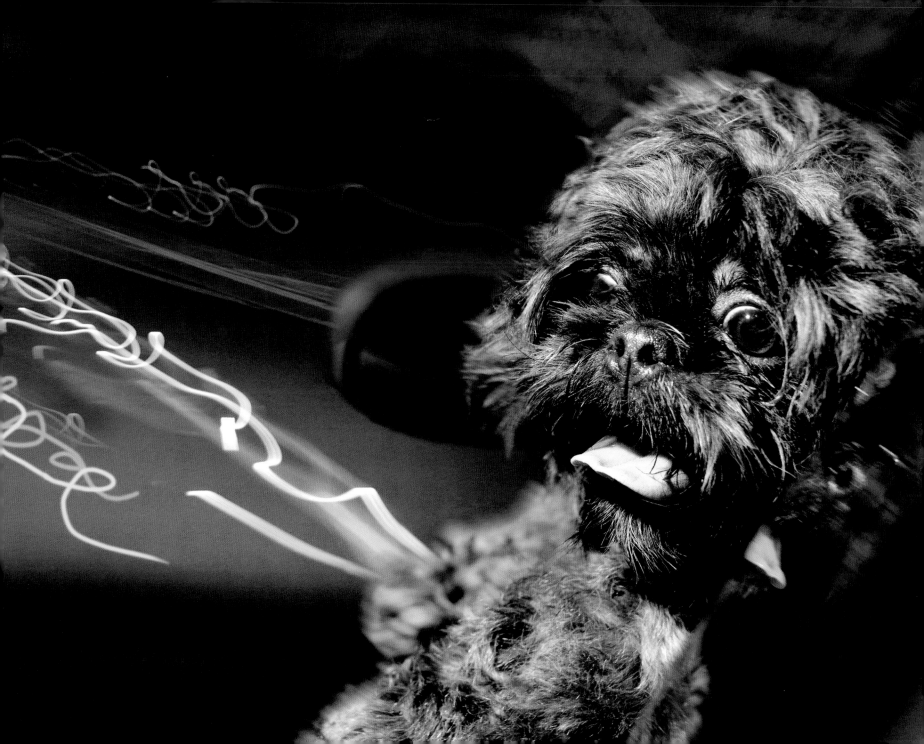

RILEY, DAISY & UNCLE MAX *Poodles*

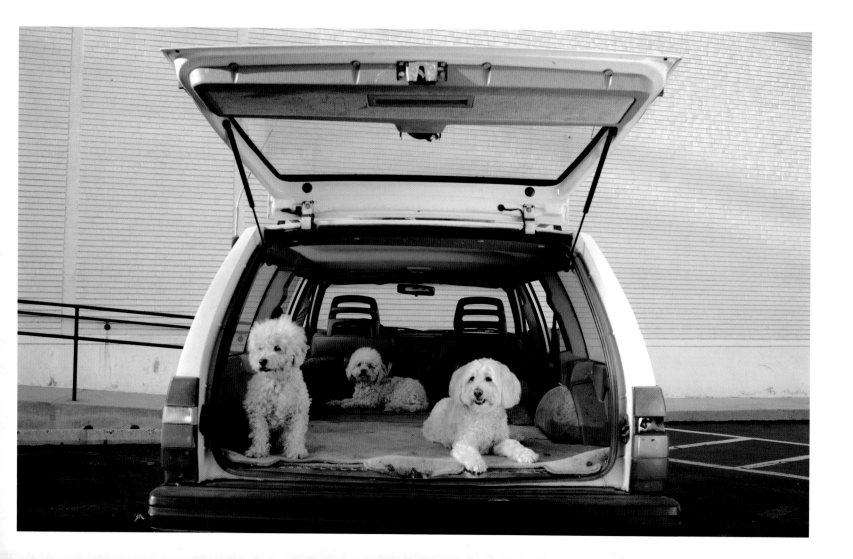

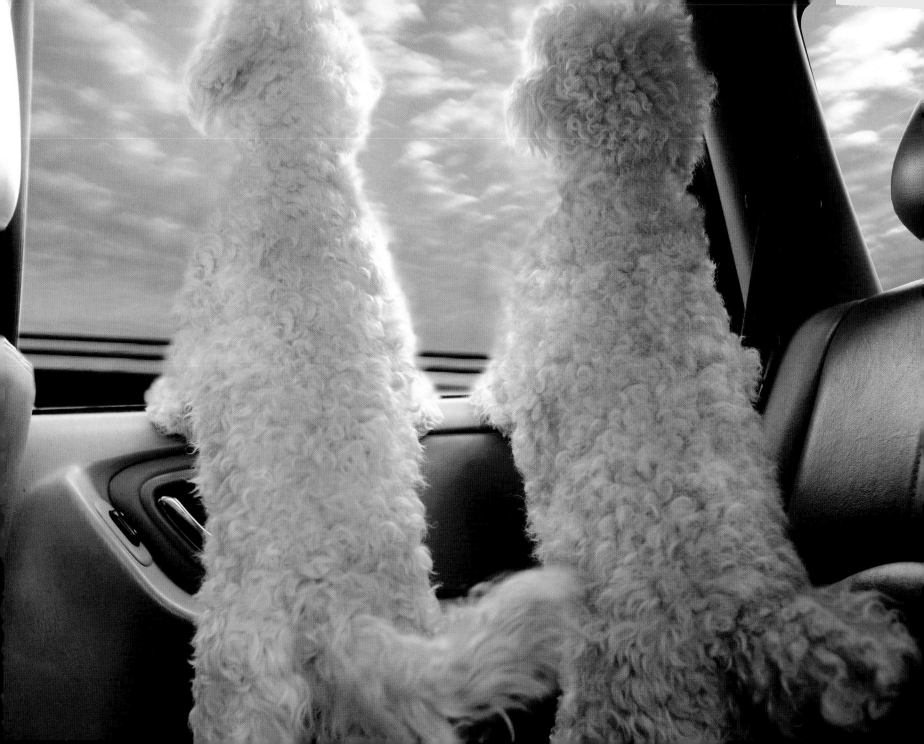

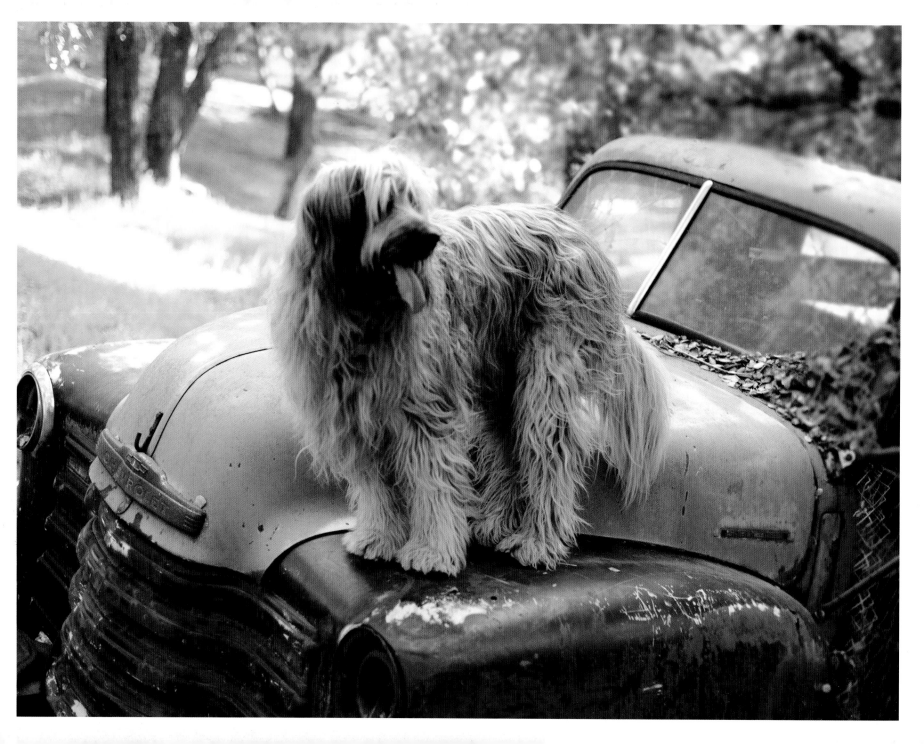

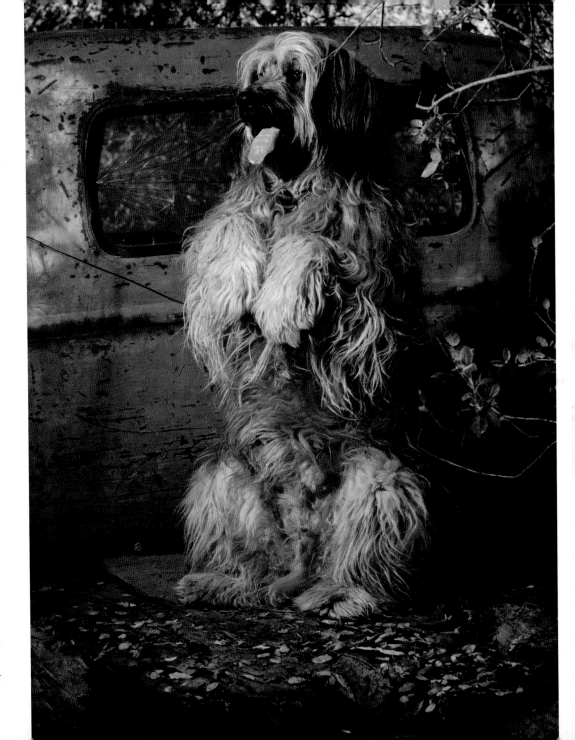

BUSTER CORNBREAD

Briard-Golden Retriever Mix

DECEMBER *White Labrador*

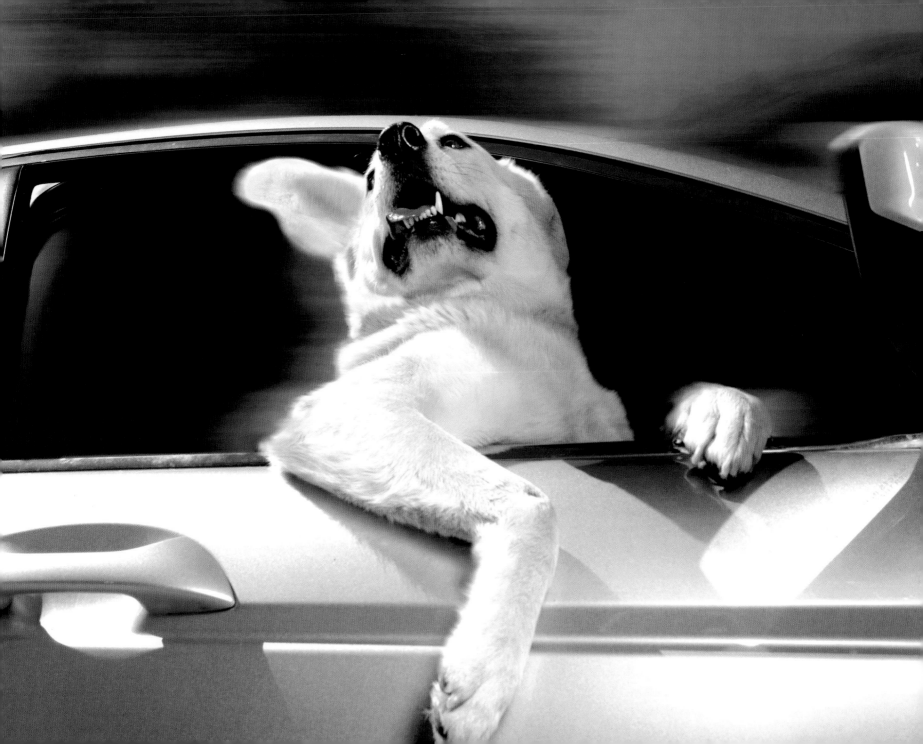

WILLOW *Yorkie Mix*

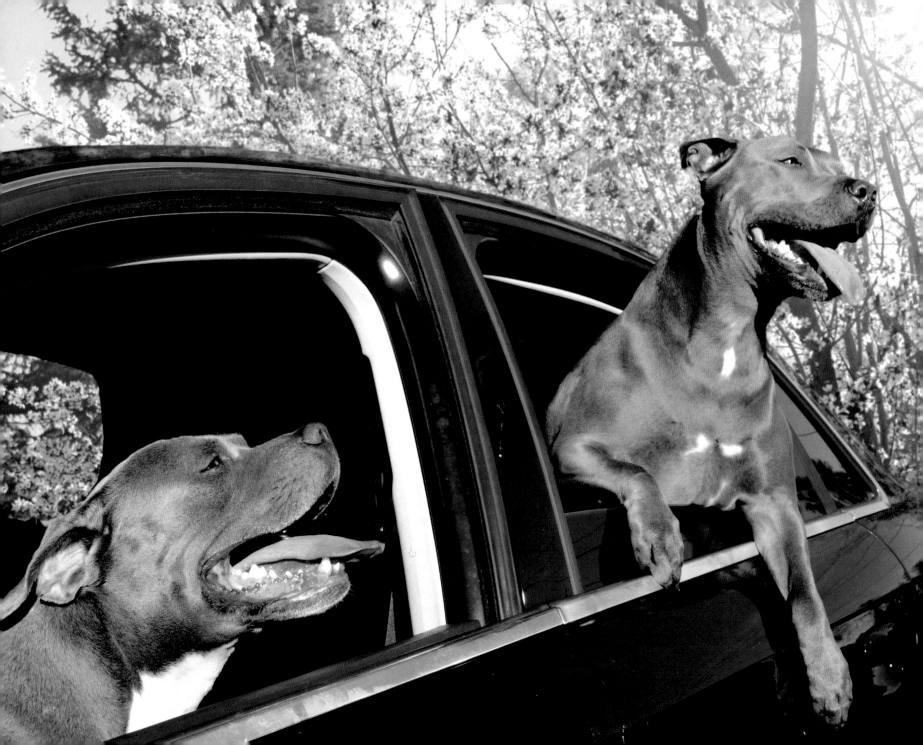

GRADY & DONNA *American Staffordshire Terriers*

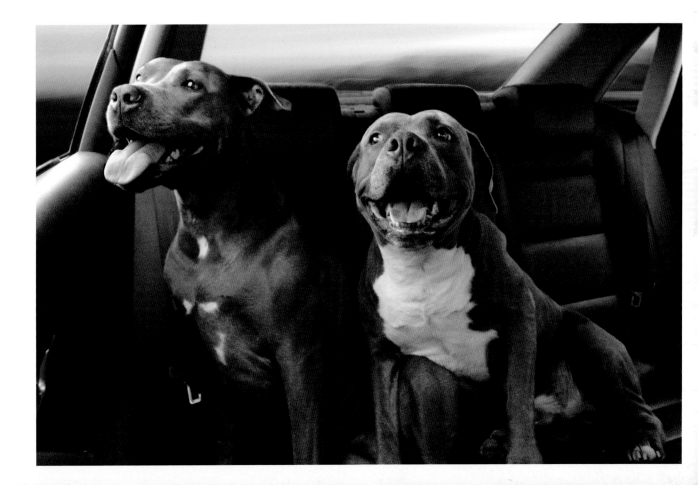

GRADY & DONNA'S POINT OF VIEW

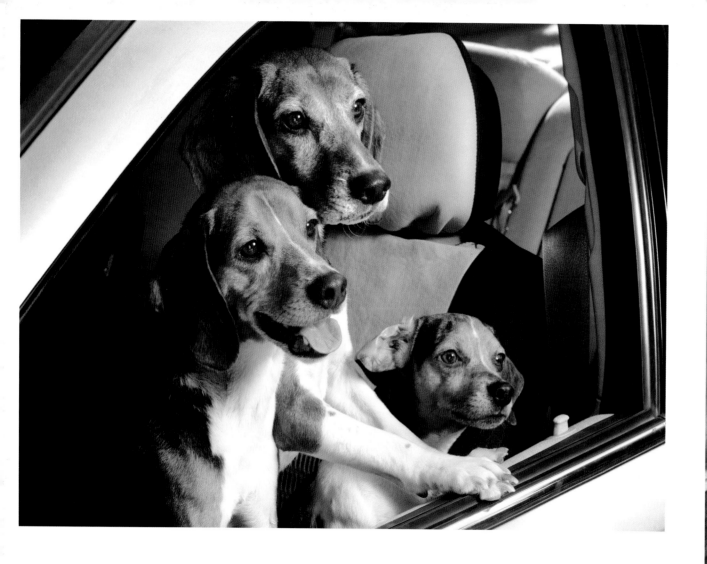

MUDBALL, ROMEO & KELLY *Pocket Beagles*

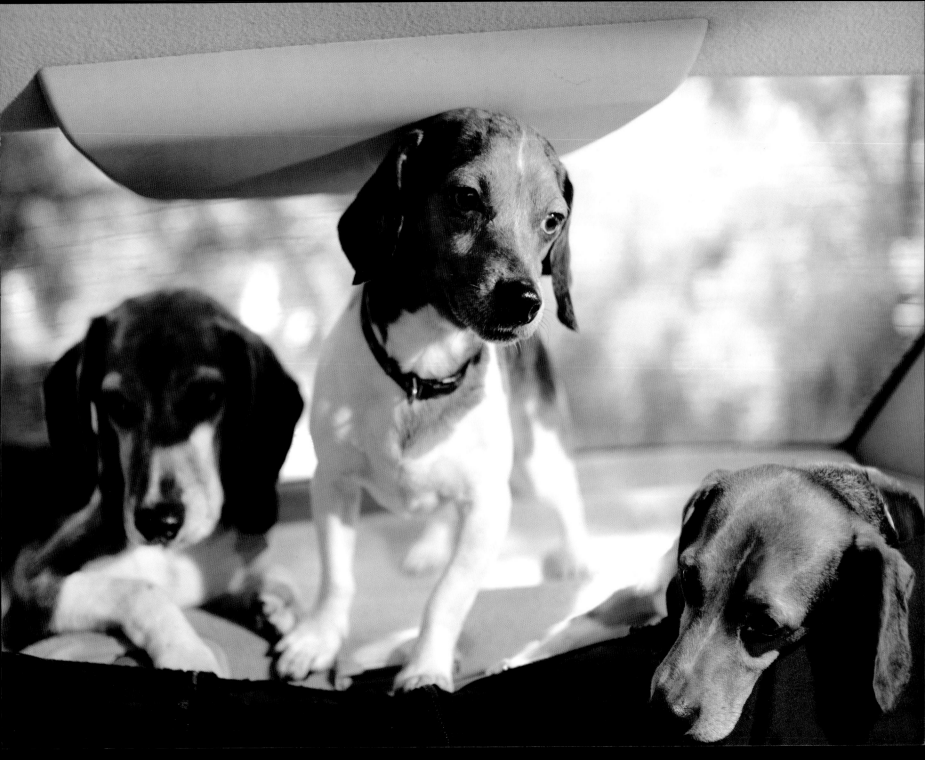

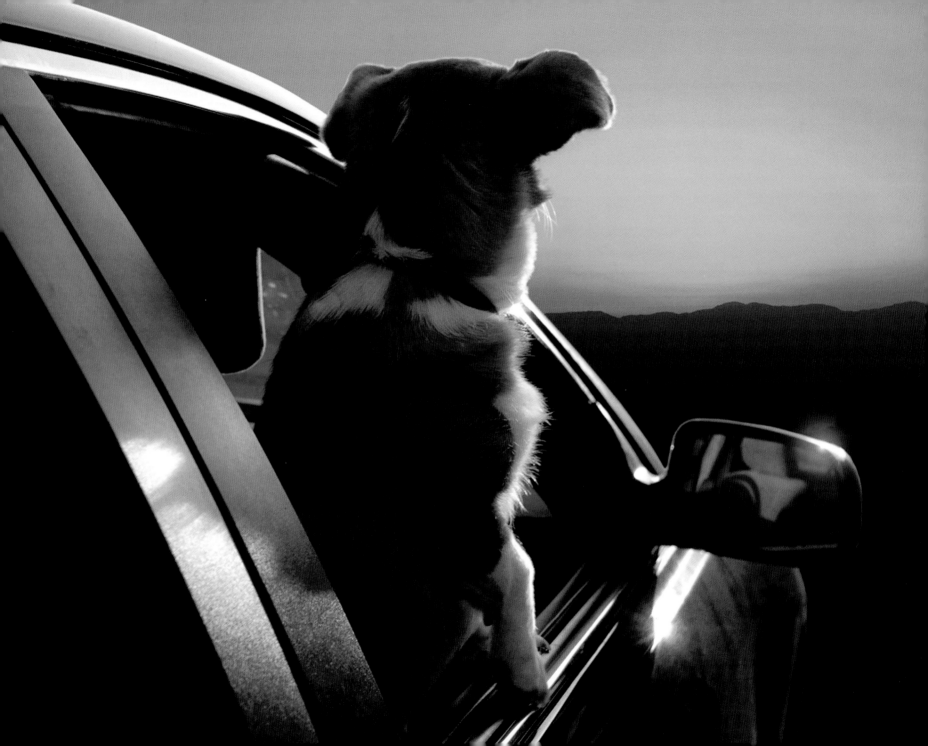

THOR *Pembroke Welsh Corgi*

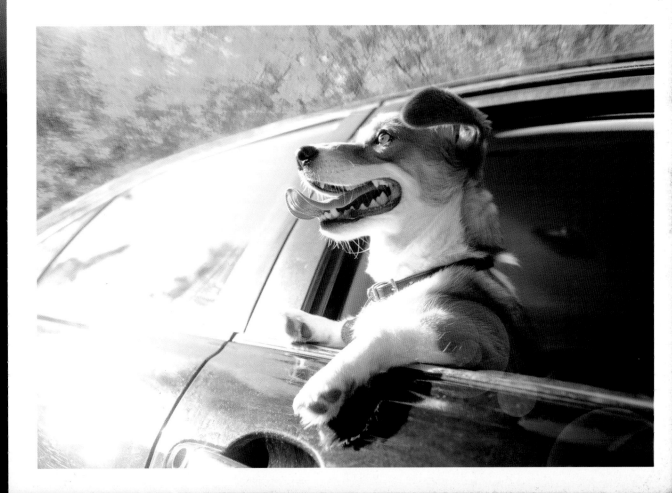

BOB *Olde English Bulldogge*

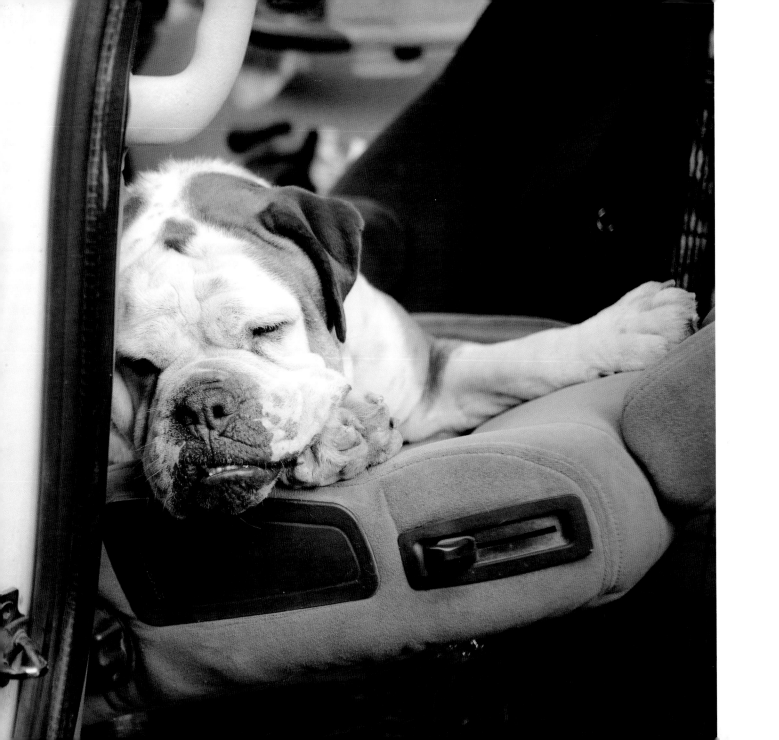

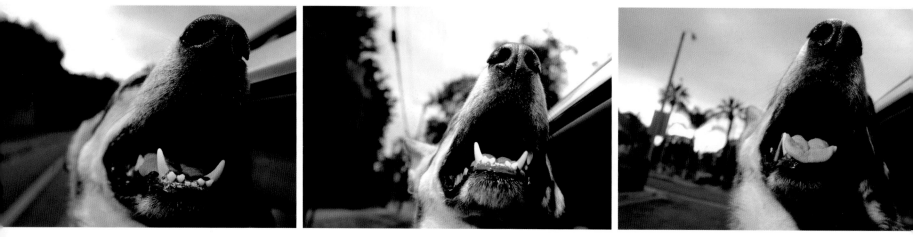

CRANE *German Shepherd*

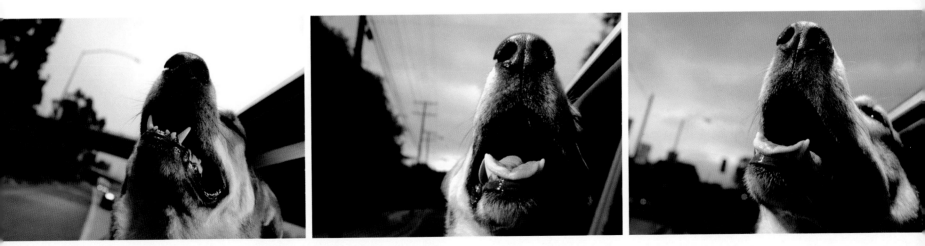

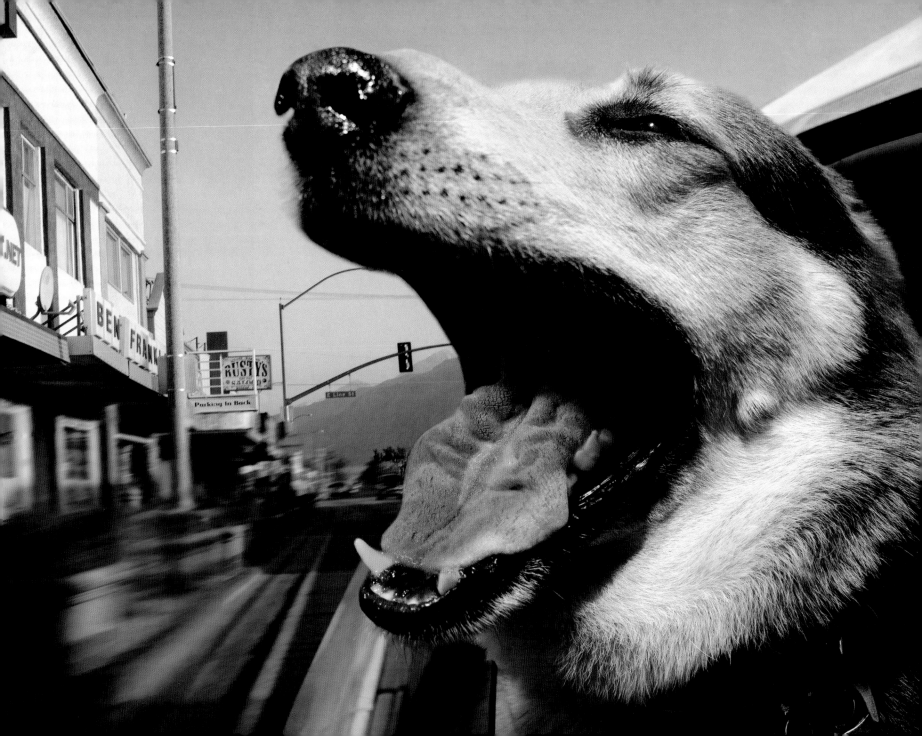

LILLY & ELEANOR *Maltipoo & Newfoundland*

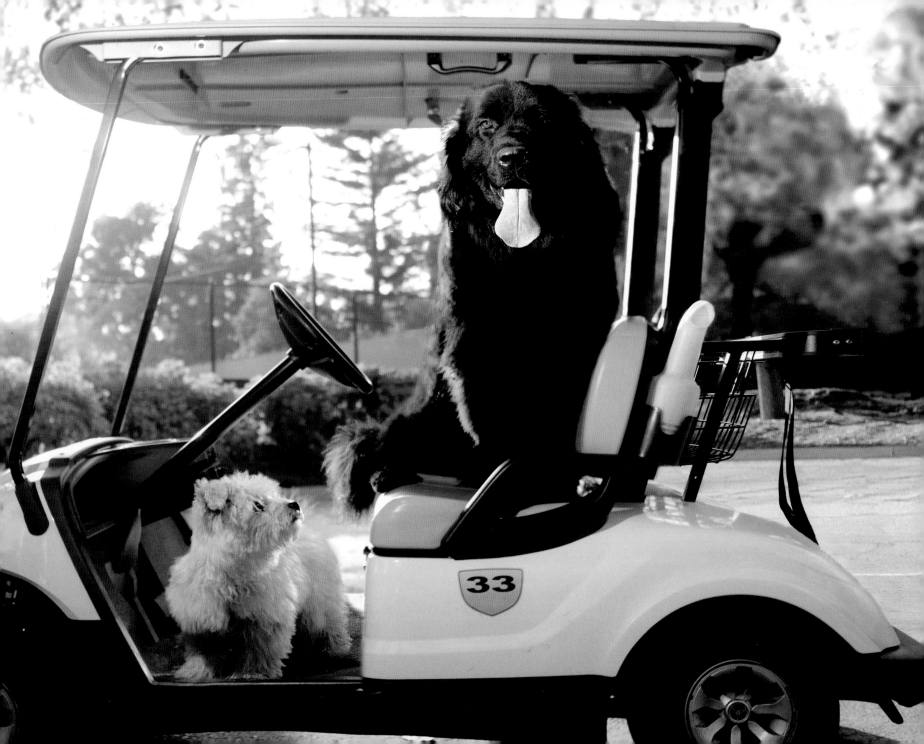

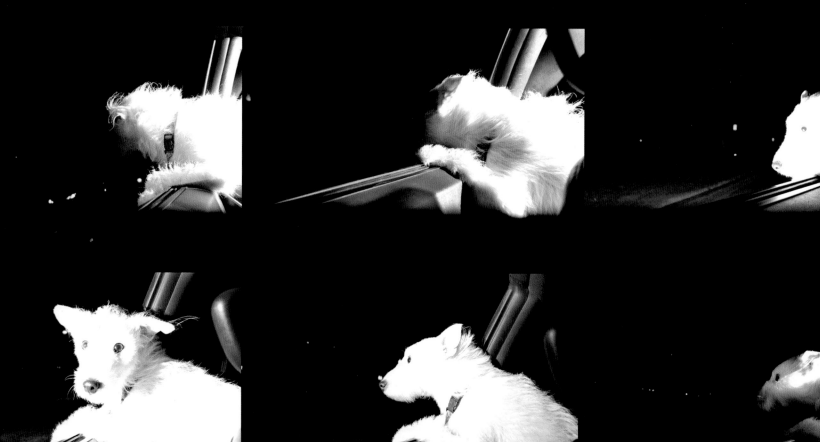
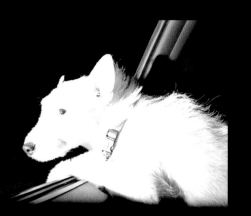
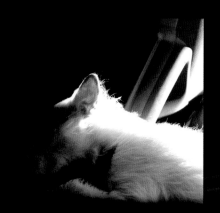
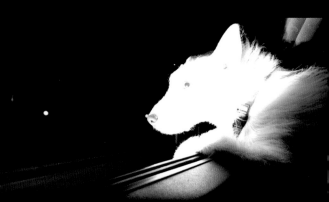

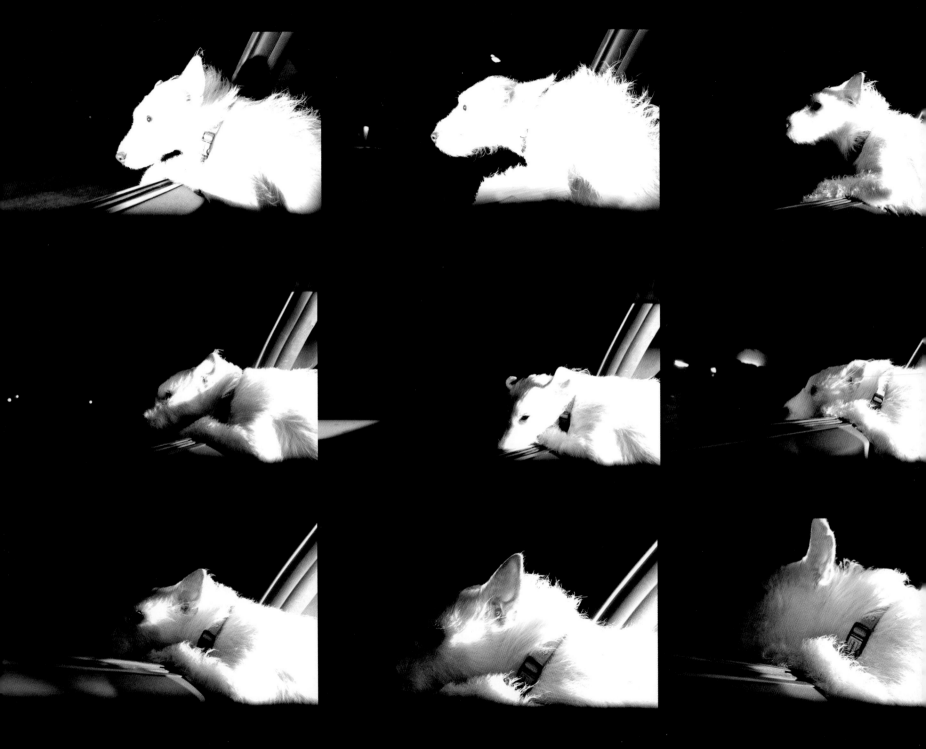

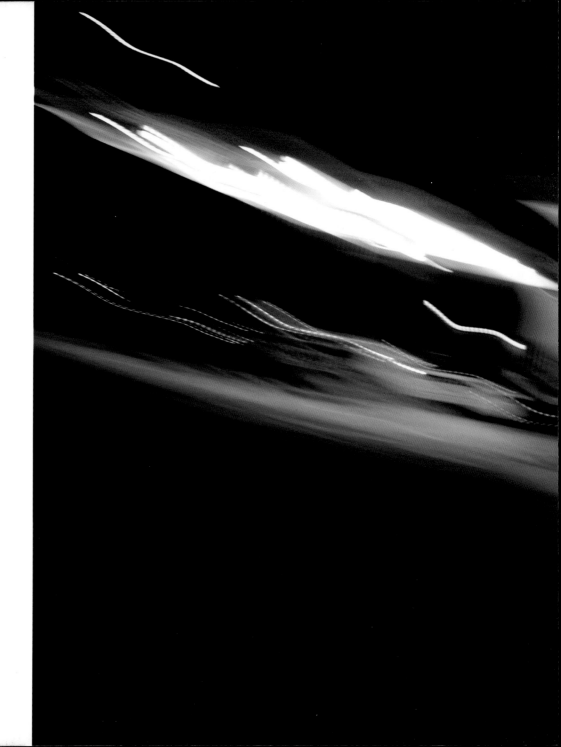

ROCKY *Wirehaired Jack Russell Terrier*

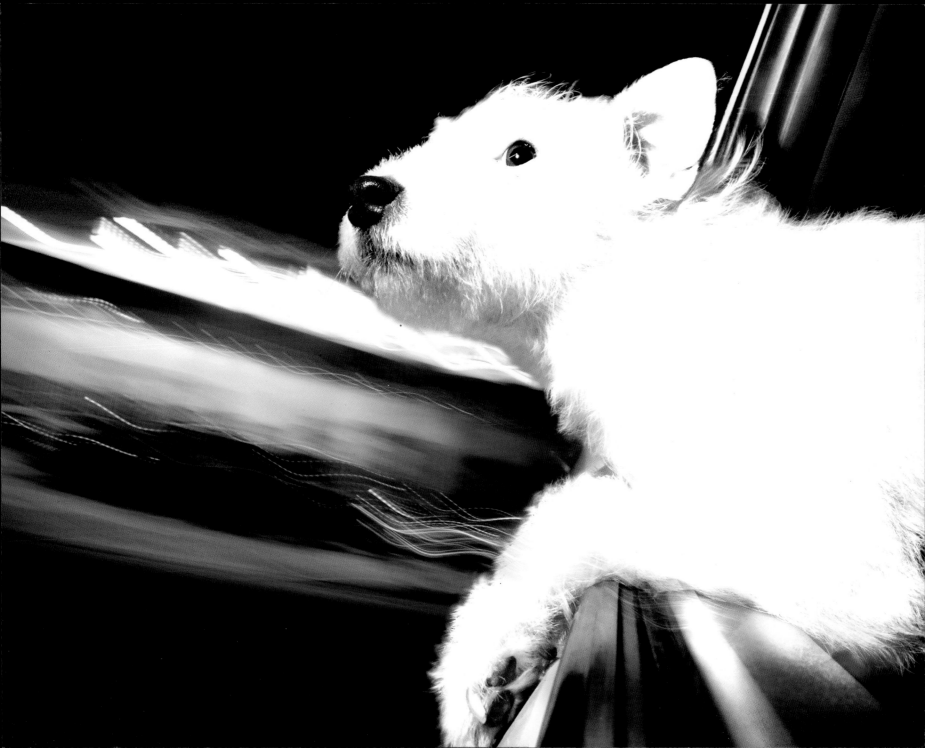

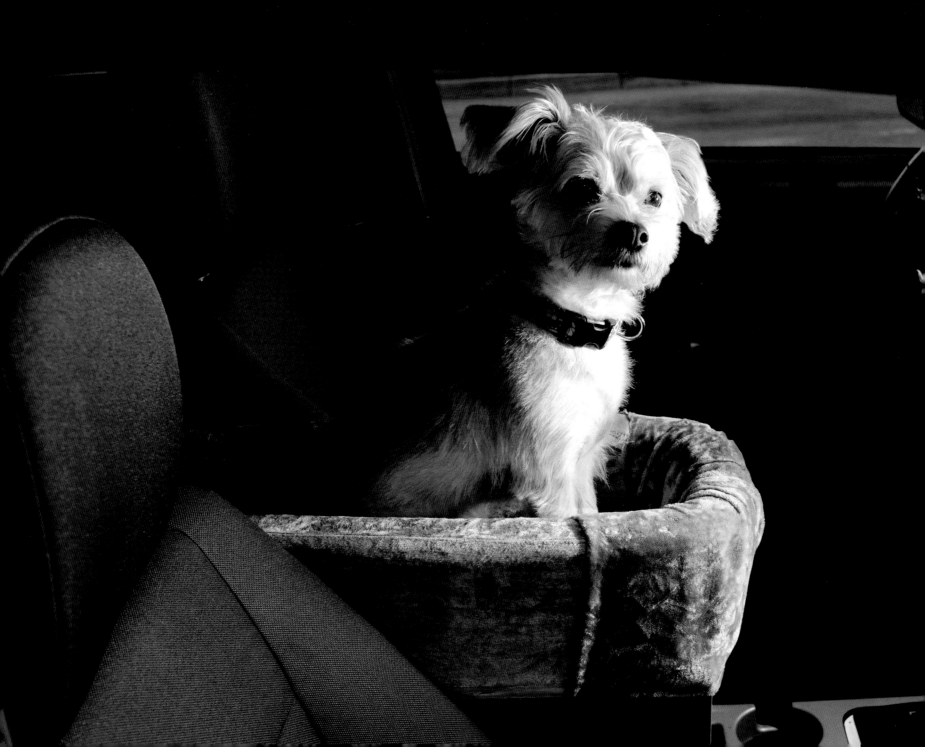

SAMMY *Mutt*

Johnny's Ride to the Dog Park

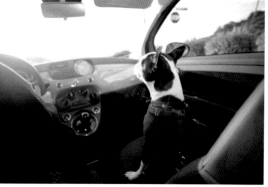
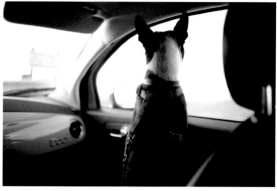
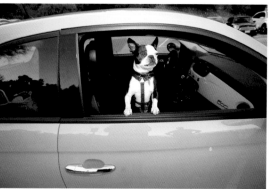
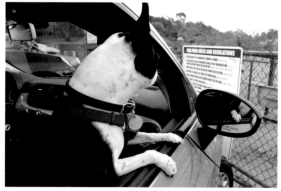
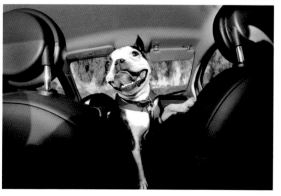

JOHNNY *Boston Terrier*

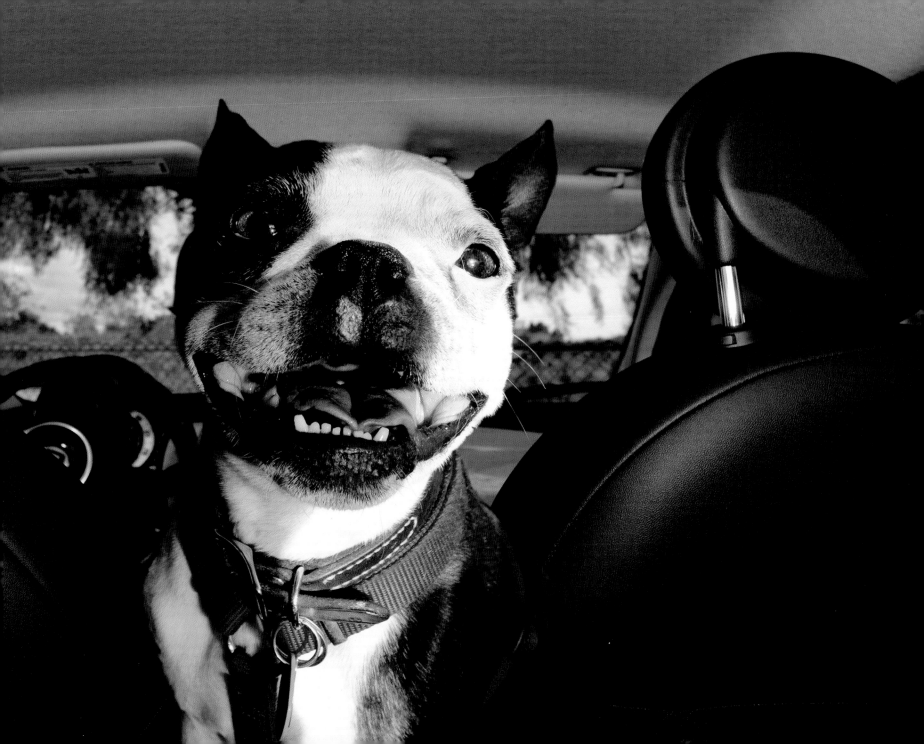

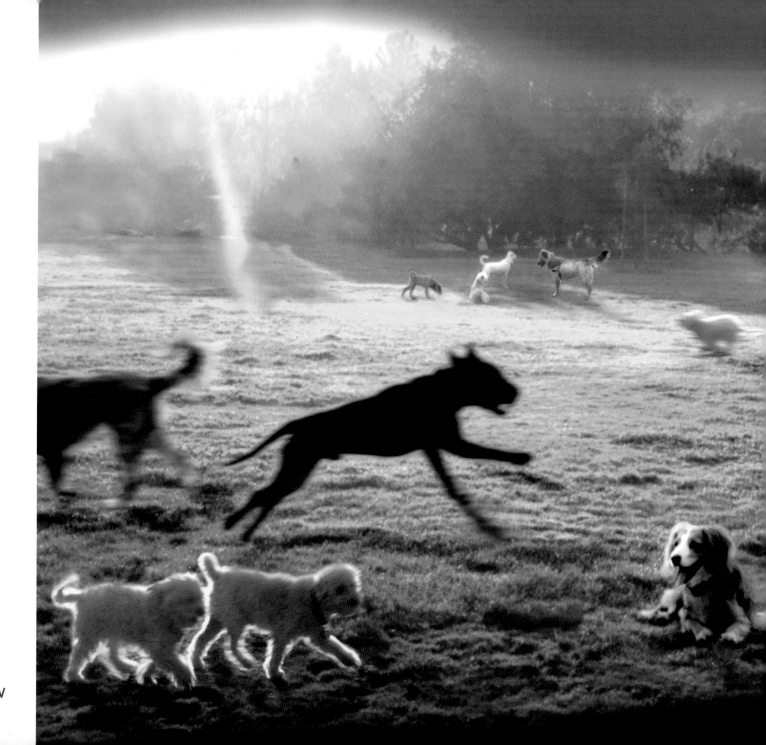

JOHNNY'S
POINT OF VIEW

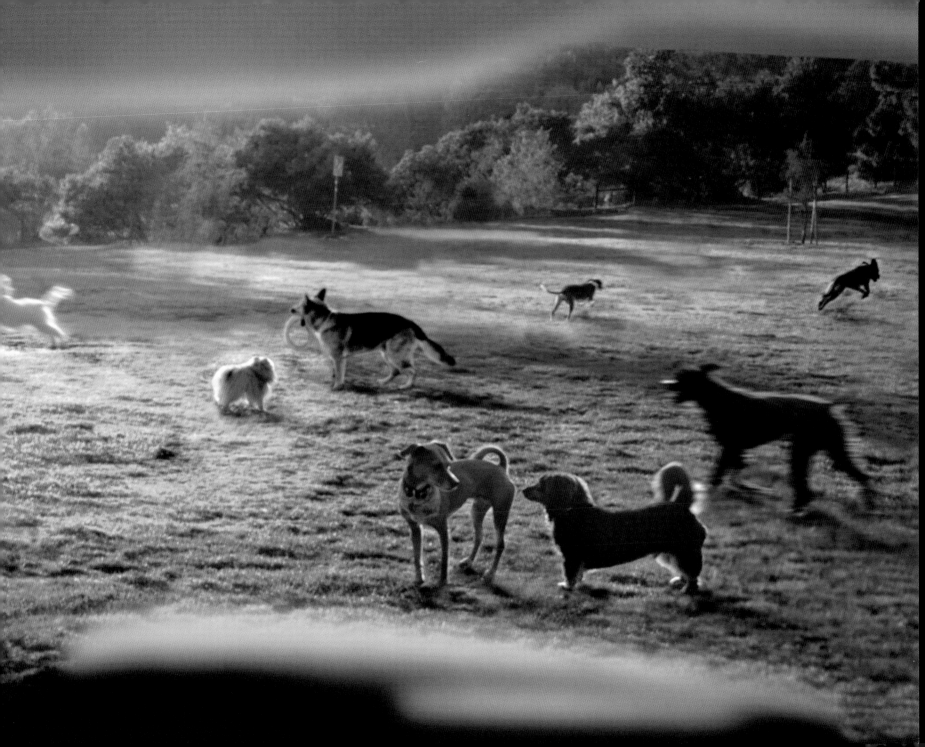

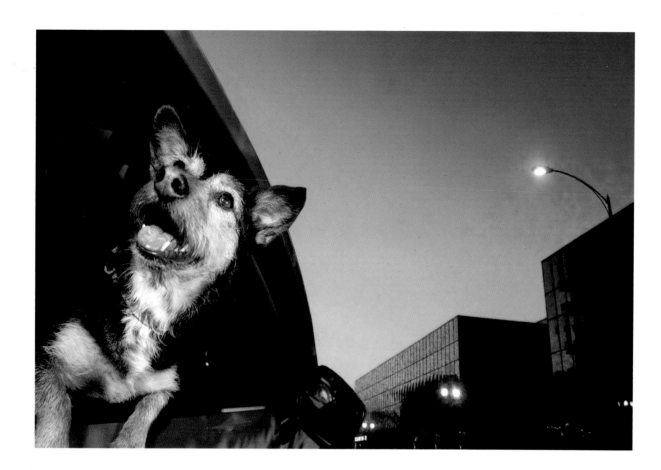

ELIZA *Pembroke Corgi-Terrier Mix*

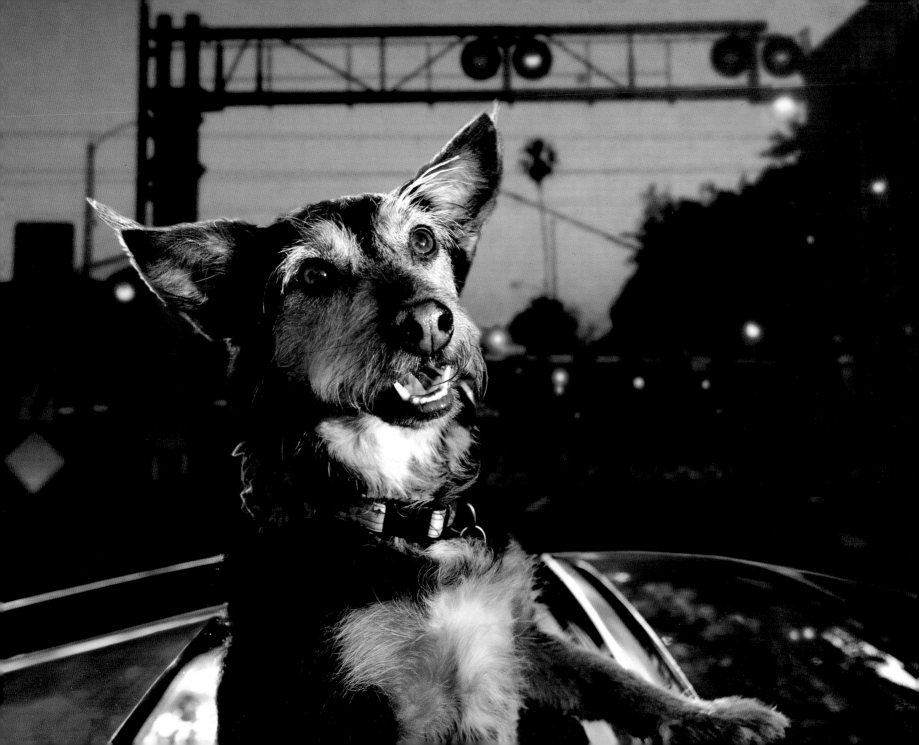

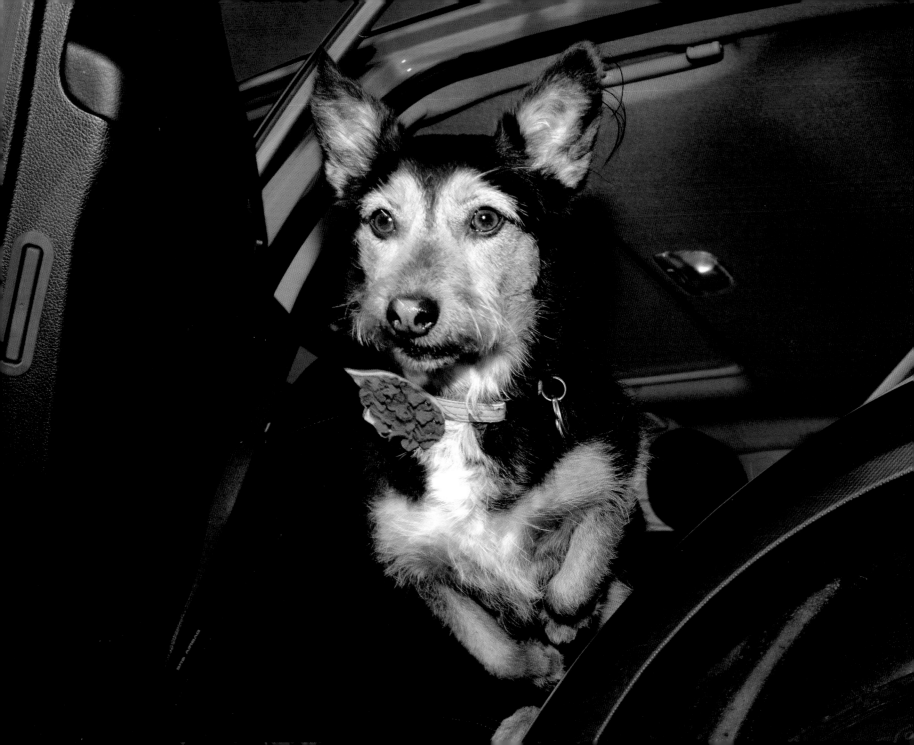

Make, Model & Year

CHAMP & JORDAN, ages 4 & 3,
Golden Retrievers in a
2010 Toyota Matrix

CHULO, age 8,
Dapple Chiweenie in a
2014 Toyota Prius

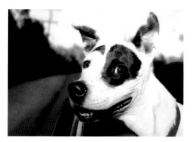

BOO, age 3, Pit-Terrier Mix in a
2008 Chrysler Sebring

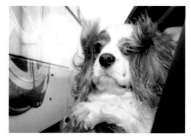

OLIVIER, age 4,
King Charles Spaniel in a
2013 Hyundai Elantra

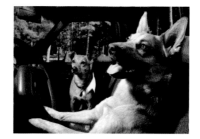

TWYLA & BLU, ages 4 & 16
months, Queensland Heeler & Jack
Russell-Chihuahua Mix in a 1987
Ford Ranger

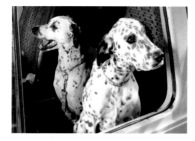

WESLEY & SNICKERS,
age 2, Dalmatians in a
1974 Chevy G10 Sportvan

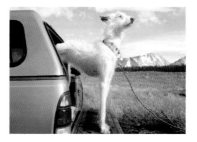

TATUM, age 5 ,
Wirehaired Ibizan Hound in a
2002 Toyota Tundra

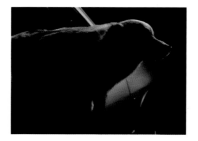

SKID, age 5,
Australian Shepherd in a
2004 Mazda Tribute

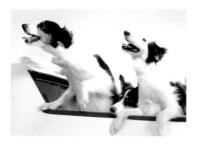

INDY, BRODY & JACK,
ages 13, 1 & 6,
Australian Shepherds in a
2006 Honda Ridgeline

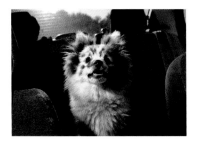

SONIC, age 6 months,
Silver Merle Pomeranian in a
2005 Honda Civic

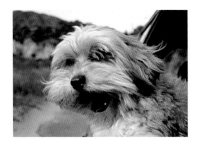

MARS, age 8,
Lhasa Apso-Poodle Mix in a
2007 Nissan Versa Hatchback

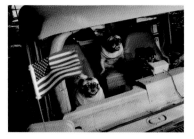

NAPOLEON, LULU & STITCH,
ages 9, 8 & 9, Pugs in a
1984 CJ7 Military Clone by
Guy Nichols and a
1983 Volvo 245 Turbo Wagon

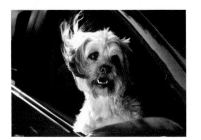

FLOYD, age 3,
Maltese-Havanese Mix in a
2012 Toyota Prius

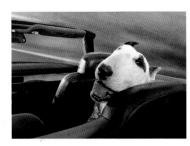

DUGAN, age 6,
English Bull Terrier in a
1996 Jaguar XJS Convertible

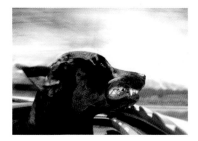

COUNT NUTSFORD, age 3,
Lab Mix in a 2008 Toyota 4Runner

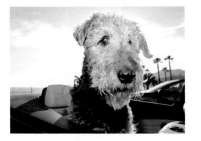

ERNIE, age 7,
Airedale Terrier in a
2008 135i BMW Convertible

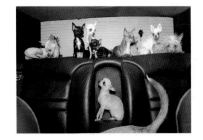

THE MARIA-CHI-CHIS,
ages 5 months–12 years,
Chihuahuas in a
2002 Mercury Grand Marquis

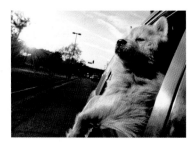

BEAR, age 11,
Chow-Husky Mix in a
2005 Honda Pilot

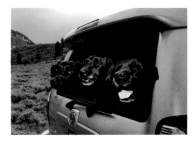

JAKE, LOHTSE & LUCKY,
ages 12, 6 & 2, Black Labradors in a
2008 Toyota 4Runner

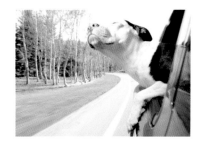

PICKLES, age 18 months,
Pit-Staffordshire Mix in a
2003 Toyota Tacoma

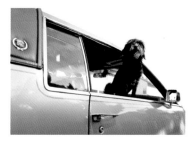

DIEGO, age 2,
Miniature Schnauzer in a
1979 Cadillac Eldorado

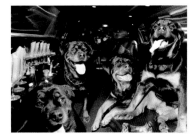

ROTTWEILERS,
ages 7 months–5 years in a
2007 Lincoln limo

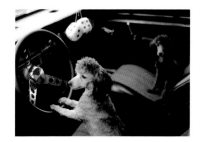

OPAL & CUPID,
ages 7 months & 11 months
Toy Poodles in a 1964 Dodge Dart

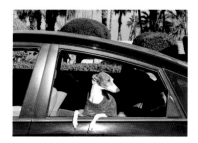

MARLEY, age 8,
Italian Greyhound in a
2014 Toyota Prius

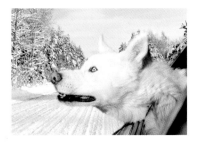

SASHA, age 3,
Siberian Husky in a
2005 Subaru Legacy

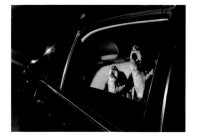

ELVIS & PRESLEY, age 7,
Dachshunds in a
2003 Honda Accord

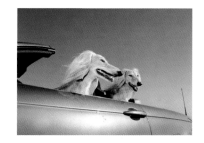

REEM & RASHEED,
age 6, Salukis in a
2004 BMW 330Ci Convertible

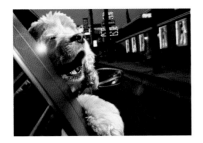

MIKEY, age 5,
Cocker Spaniel in a
2011 Ford Fiesta

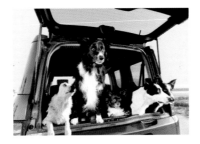

BLITZ, SKETCH, EEVEE, TORCH,
FLASH, ages 3–7, Border Collies,
Chihuahua Mix & McNabs, in a
2007 Honda Element

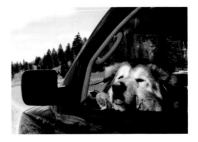

MYSTIC, age 3, Great Pyrenees-
Alaskan Malamute Mix in a
2008 Infiniti QX56

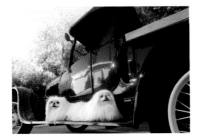

DIVA PEARL & SHOKO MOKO,
ages 10 & 6, Pekingese, in a
1927 Model-T Ford and a
Toyota RAV4

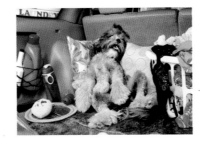

BARE, age 2,
Wheaton Terrier-Poodle Mix in a
2003 Mazda Tribute

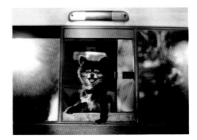

BEARLIE, age 8,
Toy Pomeranian in a
1998 Ford Pickup Truck

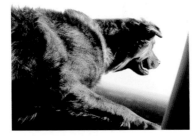

HUCKLEBERRY, age 4,
Lab-Shepherd Mix in a
2007 Nissan Versa Hatchback

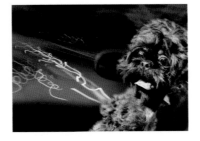

JESSE, age 6,
Chinese Imperial Shih Tzu in a
2004 Volvo S60

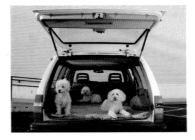

RILEY, DAISY & UNCLE MAX,
ages 7, 2 & 10, Poodles in a
1988 Volvo Wagon and a
2002 Mazda Tribute

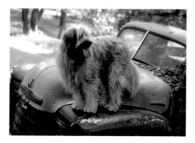

BUSTER CORNBREAD, age 6,
Briard-Golden Retriever Mix on a
1949 Chevrolet Flatbed truck

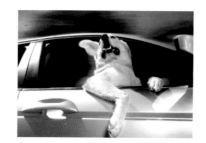

DECEMBER, age 6,
White Labrador in a
2012 Honda Accord

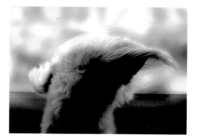

WILLOW, age 1, Yorkie Mix
in a 2011 Ford Mustang

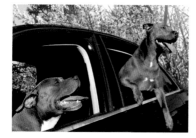

GRADY & DONNA, ages 5 & 4,
American Staffordshire Terriers
in a 2007 Audi A4

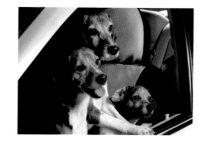

MUDBALL, ROMEO & KELLY,
ages 4, 5 & 5, Pocket Beagles in a
2004 Saturn L300

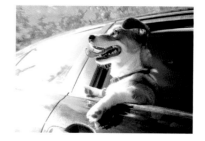

THOR, age 3,
Pembroke Welsh Corgi in a
2007 Toyota Camry

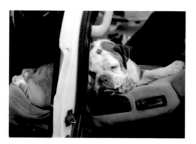

BOB, age 2,
Olde English Bulldogge in a
1998 Pontiac Trans Sport Van

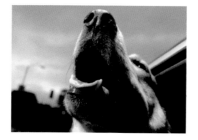

CRANE, age 8, German Shepherd
in a 2006 Subaru Outback

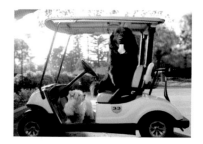

LILLY & ELEANOR,
ages 4 months & 13 months,
Maltipoo & Newfoundland in a
Yamaha Golf Cart

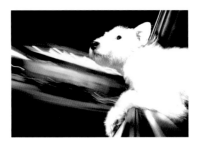

ROCKY, age 6 months,
Wirehaired Jack Russell Terrier in a
2013 Dodge Challenger

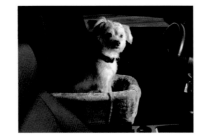

SAMMY, age 3, Mutt in a
2012 Ford Escape

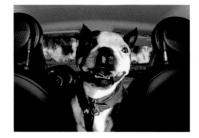

JOHNNY, age 8,
Boston Terrier in a
2013 FIAT 500 Pop

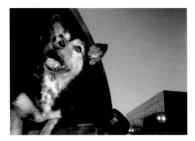

ELIZA, age 4,
Pembroke Corgi-Terrier Mix in a
2013 Subaru XV Crosstrek

Photographing Your Dog

When it comes to photography, we've all heard the old adage, "Never work with children or animals." When it comes to photographing dogs, I beg to differ. Dogs are so naturally beautiful, spontaneous and comical, they actually make ideal photographic subjects.

The truth is, dogs are not much different than people when it comes to their relationship with a camera. Some *love* being photographed, others can't be bothered. One of my favorite canine muses used to prance around the set with delirious excitement the minute I started setting up my lights. Perhaps he was anticipating the fresh chicken strips he would be rewarded with during the shoot (yes, treats always help). But a trainer friend attributed this behavior to less primal motives. He explained that dogs are natural-born pleasers: they love to have jobs. Some regard fetching as their official form of employment—which is why they will retrieve a ball for you, over and over—while others may prefer posing for pictures instead, lapping up the attention and approval they get in the process.

I don't recommend trying to manipulate any dog who does not have a natural inclination to perform for you in front of a camera. Instead, use a more documentary approach by photographing your pet's naturally occurring moments, such as when they are napping, playing or pleading for table scraps. Believe me, these authentic situations are bound to produce far more interesting and surprising photographs than anything you could force or set up, and your dog will remain comfortable and stress-free.

If you must photograph your pet in a more set-up studio-like situation, such as for a formal holiday portrait, try to have everything worked out (lighting, composition, angle, etc.) before your dog enters the frame. That way you won't burn through what little time and attention your pet may grant you before becoming bored and restless. For certain dogs, this can sometimes be only a matter of seconds. In my studio, I often use a stuffed animal the size of the dog I'm

about to photograph as a stand-in. That way I can stabilize all the other variables so when the actual dog walks on the set, I need only focus on capturing a great expression, gesture or moment.

And just like humans, some dogs are naturally photogenic, while others need enhancement to make their cuteness and beauty shine through. Of course, it helps to be equipped with professional technical knowledge to pull this off, but learning the finer points of photography can take a lifetime. Most of the images in this book required elaborate lighting setups, expensive equipment, assistants and serious safety measures. It's not something you should even attempt—especially in a moving car—unless you're a professional. However, there are simpler, inexpensive methods—the same ones used to make professional-looking portraits of humans—that can boost the natural beauty of any canine muse.

Diffused light shaped by a window frame or open door is one of the most classically beautiful forms of illumination, so long as no direct sunlight is hitting the subject. Some of the old Dutch masters like Vermeer posed their models in this kind of light, which can have a sumptuous, painterly quality. It is also a great setting to photograph your dog in, because many pets are already inclined to gaze out of windows and wait by doors. Just because you are inside does not mean you have to use a flash. In fact, built-in camera flashes tend to wash the soul right out of a picture and can make your dog's eyes look like they belong to a vampire timber wolf.

Capturing your dog outdoors works well, especially if you know a few tricks. The easiest one is to take pictures of your dog outside at magic hour—that brief period of time before the sun sets when the gentle, golden amber light can make even a sewer rat look sublime. Since dogs often take walks at this time and are in a good mood, it's the ideal time to capture a moment. Just wait until your dog steps into a band of this beautiful light, and click away.

If that's not an option, you can use the shade of a tree on a sunny day. That method will yield a similar effect as an open door or window, as long as the light is coming predominantly from one direction.

If you want to use direct sunlight, I suggest you invest in a silver or gold reflector disc. (These are inexpensive and can be purchased at most any retail camera outlet.) Position yourself so that the sun is hitting your dog from behind or from the side (or somewhere in between), and then reflect the sunlight back onto his front side with the disc. You will also need to have something to block the direct light from hitting the lens, like a piece of cardboard or a friend's hand.

The reflected light will give your dog a luminous glow, while the rear direct sunlight will create a gorgeous highlight on his fur, giving the image dramatic dimension. A similar effect can be achieved by replacing the disc with "fill light" from a semisophisticated strobe or flash.

Don't get too hung up on the notion that there is a correct way to light a dog—or anything for that matter. It depends on what you are trying to express. A flash failing to fire might result in a mysterious semi-silhouette of your pup that is more moving than the high-key commercial look achieved with strobes that show everything in graphic detail. Other technical mishaps like a blurred image can be lyrical and poetic. Embrace the happy accident!

If you're trying to photograph your puppy, be patient and don't expect perfection. Younger dogs, though generally more enthusiastic, are more likely to frantically jerk all over the place, making it nearly impossible to focus. Wait a few years, or photograph an older dog. Nothing can replace the wise, soulful expression of a hound with a few years under his collar.

If you want to dress up your dog, you should remember that comfort is as important as style. Always keep in mind that dogs cannot cool themselves as efficiently as we do, so nonporous materials like vinyl are an absolute no-no, as

is anything too tight. Put the costume on right before you snap the photos, and take it off immediately afterward. Consider the personality and coloring of your dog before choosing his garb, just as any fashion-conscious human would do!

Above all, work with the unique attributes and inclinations of your dog, never forcing him to do anything he does not want to do. He will let you know when he's had enough, and you should respect his wishes. If he associates being photographed with fun and excitement, he is much more likely to cooperate with you throughout his fabulously photogenic life.

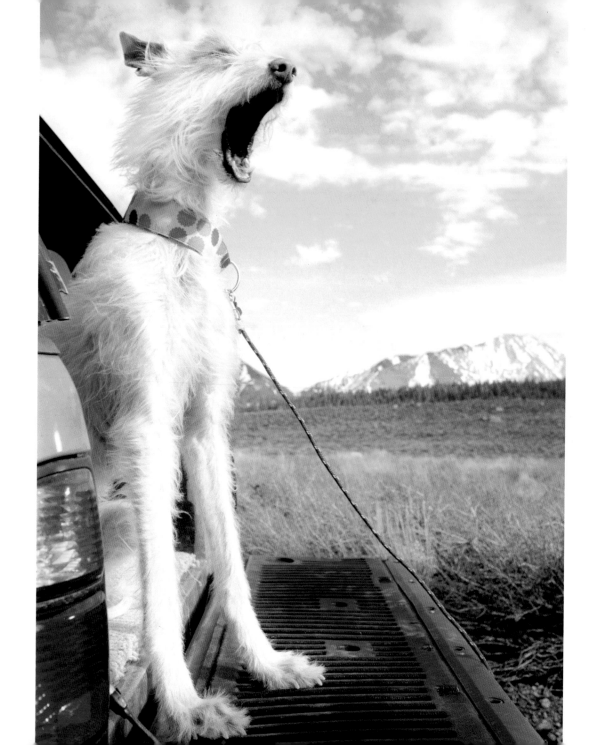

Acknowledgments

Many thanks to all the gorgeous and charismatic dogs who participated in this project. I fell in love with each and every one of you. I am equally grateful for the cooperation and assistance of your wonderful human guardians. The love and enthusiasm they have for you was truly moving.

My editor, Ann Treistman, for your dogged belief in this project, and the team at Norton and Countryman for their many contributions. A special thanks to Michael Levatino for discovering my project.

David and Dannie DiMichele, for your unwavering support on all fronts, and for putting up with the unpredictable demands of my creative ventures. You're a true sport, David, for concocting my special lighting contraption and installing it on many a car roof.

California, for your stunning, diverse landscape, which made it possible to photograph this entire book without crossing state lines.

All those out there in cyberspace who shared my original *Dogs in Cars* images that led to so many glorious things.

Traci Walker, for rounding up an awesome array of canine characters up in snow country, and for letting us stay in your cozy cabin, even after Uncle Max relieved himself on the rug, twice.

Vicki Gatusso, for traveling all the way from South Carolina with your otherworldly Pekingese charges.

Jennifer Lewi and Johnny, for your special contribution and friendship.

My mother, for passing on the beauty and humor she saw in animals, something I aspire to keep alive through my work. I miss sharing my pictures with you.

The many kind and generous souls helping to rescue dogs and find them loving homes, many of whom participated in this book. And all the other humans toiling in relative obscurity to raise awareness of the profound value of all the other magical creatures we share the earth with, and how impoverished our existence would be without them. Your efforts are a constant source of inspiration.

 No dogs were harmed during the production of this book. The utmost care was taken to ensure the comfort and safety of all creatures involved, requiring the expertise of several professionals. Please do not try this at home or, in this case, on the road.

About Lara Jo Regan

Lara Jo Regan is a photographer, filmmaker and curator whose diverse career spans the magazine, fine art and journalistic worlds. She honed her skills as a regular contributor to the world's leading publications, such as *Time*, *Newsweek*, *Entertainment Weekly* and *Life*, winning many of the field's top honors, including *Communication Arts* accolades, Pictures of the Year awards and the coveted the World Press Photo of the Year.

Her career took an unexpected detour after a photo series she created of her rescued pup Mr. Winkle made Internet history, becoming one of the very first global viral sensations, transforming her pet into the first four-

legged cyberspace celebrity and attracting record crowds at his book signings. Her groundbreaking animal photography and other work is widely published, collected and exhibited.

Dogs in Cars is her fifth photography book celebrating the beauty and wonder of dogs.

Regan is a longtime resident of Southern California, where she lives with her family.

To learn more please visit:
www.OfficialDogsInCars.com
www.LaraJoRegan.com